IMAGES
of America

LAFAYETTE
SQUARE

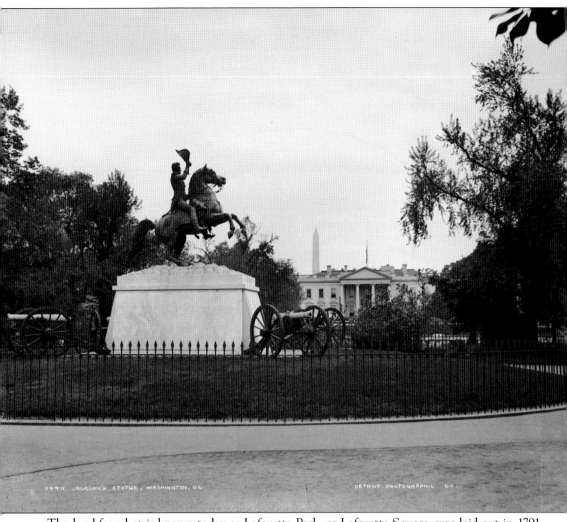

The land for what is known today as Lafayette Park, or Lafayette Square, was laid out in 1791 by Pierre L'Enfant as part of the pleasure grounds surrounding the Executive Mansion. The site was designated President's Square. Architect Charles Bulfinch designed the park's first planting scheme in 1821. The park was officially named for visiting French general Marquis de Lafayette when a parade in his honor ended at the square in 1824. (Courtesy of Library of Congress, Prints and Photographs Division.)

ON THE COVER: Shown in 1913, the grounds of Lafayette Park were still the heart of a fashionable, cosmopolitan neighborhood of politicians, cabinet members, businessmen, authors, and philanthropists whose proximity to the White House was seen as essential to their status. This would begin to change within 20 years, as residences were converted to commercial and governmental uses. (Courtesy of Library of Congress, Prints and Photographs Division.)

IMAGES
of America

LAFAYETTE
SQUARE

Lonnie J. Hovey

ARCADIA
PUBLISHING

Published by Arcadia Publishing
Charleston, South Carolina

Printed in the United States of America

Library of Congress Control Number: 2013957041

For all general information, please contact Arcadia Publishing:
Telephone 843-853-2070
Fax 843-853-0044
E-mail sales@arcadiapublishing.com
For customer service and orders:
Toll-Free 1-888-313-2665

Visit us on the Internet at www.arcadiapublishing.com

To Eileen, my loving wife and partner.
With you in my life, all things seem possible.

CONTENTS

ACKNOWLEDGMENTS

The buildings and sites where we live and work have, for the most part, interesting histories that predate our involvement with them. These unknown prehistories intrigue me to push past the faceless dates and into the individual, and sometimes mundane, stories that make these places come alive. This book aims to capture these stories and to connect the past to our present lives in the world around us.

This book would not have been possible without the assistance of my editors at Arcadia Publishing, Lissie Cain and Julia Simpson. I want to thank all the curators and museum staff involved with The Neighbors to the President Consortium, whose help in developing walking tours of the Lafayette Square neighborhood was extremely useful in the genesis of this book's development. The staff and resources of the White House Historical Association were invaluable during the compilation of this book. Nearly all of the images in these pages are found and reproduced courtesy of the Library of Congress (LOC) Prints and Photographs Division, unless otherwise noted. I am extremely grateful to the staff at the LOC, Prints and Photographs Reading Room, who helped to locate rare images within the collection in order to illustrate this book. The staffs of the Commission of Fine Arts, the Historical Society of Washington, DC, and the DC Library's Washingtoniana Collection were most helpful in sharing their research and vertical files, which contained many stories of the fight to save the buildings and history of Lafayette Square in the 1950s and 1960s. I am also grateful to the valuable input provided by Paul Cummins and Max Hovey, both of who took the time to review this text and to provide suggested changes, thereby greatly improving the legibility of the historical stories contained within. Thanks go to my parents, Karen and Vaughn Hovey, for fostering a love of history, which led to my career in old buildings. Lastly, I need to acknowledge my entire family, Eileen, Max, Davis, and Quinn, for listening to the crazy and wacky tales of historical events shared over countless meals. History can be strange, but it certainly is not boring.

INTRODUCTION

Lafayette Square's rich history dates to the District of Columbia's inception, when Pierre L'Enfant planned it as part of the grounds for the President's House. The square was one of the first open spaces within the city to be designed as a public park in the 1820s. As residences were built, its neighborly character set the park apart from others in the city. Located across Pennsylvania Avenue from the White House, the surrounding neighborhood became home to presidents, vice presidents, cabinet members, diplomats, legislators, inventors, journalists, heroes, authors, scientists, lawbreakers, and scoundrels. Once an orchard and graveyard, the park and its neighboring buildings have been sites for murder and mayhem. Although the buildings surrounding the square have changed uses, the character remains. The square retains a symbolic link as the White House's front yard, which makes it a constant draw for tourists, reporters, and demonstrators. Featuring historic photographs mostly from the Library of Congress Prints and Photographs Division, this book captures the square's social, political, and architectural history so as to highlight forgotten past events.

Lafayette Square, initially farmland, was settled in 1685. A century later, much of the area had become an apple orchard and included a family graveyard. In 1792, the land was staked out as part of the grounds for the President's House, the erection of which, between 1792 and 1800, turned the land into a construction site filled with brick kilns, lime pits, and workers' huts. The space would again serve as a construction site after the British burned down the White House in 1814. Architects Benjamin Henry Latrobe and James Hoban would oversee its reconstruction between 1815 and 1817.

During reconstruction of the White House, Latrobe designed the first structure on Lafayette Square's northern edge, St. John's Episcopal Church (built 1815–1817), as well as the first residence on the square's western edge, Decatur House (built in 1818). It was unusual at the time for an architect to have so much of his work represented in such a small area. Intriguingly, this phenomenon was to occur two other times in the square's history. A century after Latrobe's dominance, architect Cass Gilbert designed the US Department of Treasury Annex at the square's southeast corner in 1919 and the US Chamber of Commerce headquarters at the northwest corner in 1922. Some 40 years after Gilbert, architect John Carl Warnecke designed the National Courts Building on the east side and the New Executive Office Building on the west side in the late 1960s.

The third structure on the square was the first for its east side. The Cutts-Madison House was built at the northeast corner between 1818 and 1819. Others soon followed. A house for Dr. Thomas Ewell was built in the middle of Jackson Place on the square's west side in 1819. A house for DC district attorney Thomas Swann was built on H Street at the northwest corner in 1828. A pair of houses soon appeared on Madison Place, one for Benjamin Ogle Tayloe in 1828, and one for Commodore John Rodgers in 1831. In 1836 and 1840, two new houses were built on H Street. A building boom in the 1860s saw more town houses installed on Jackson Place. Further construction in the 1880s filled in the remaining lots around the square. After this point, any new construction required demolition of an older structure or renovation of an existing building.

In Pierre L'Enfant's plan for the District of Columbia, the neighborhood surrounding President's Park was to house foreign embassies. A few foreign delegations did take up residence around the square, but most of the homes were occupied by cabinet members, military leaders, and members of Congress, making this a fashionable 19th-century residential neighborhood. British ambassadors occupied Ashburton House on H Street, overlooking the square's northeast corner, from 1842 until 1931. The French ambassador occupied the residence of William Corcoran, a Southern sympathizer, at the northwest corner of the square and H Street during the Civil War. A few different delegations occupied 722 Jackson Place. Between 1879 and 1881, the Chilean Legation leased the house. The Spanish Legation occupied the building from 1883 to 1885, and the Republic of Brazil's ambassador leased the house from 1908 to 1909.

In the 1880s, homes east and west of the square were converted from residences to offices or social clubs. Many more changed by the 1920s, when new buildings replaced the original homes. The Freedman's Savings Bank replaced the Gunnell House on the corner of Madison Place and Pennsylvania Avenue in 1873. The Lafayette Square Opera House replaced the Rodgers House on Madison Place in 1895. A six-story building for the Cosmos Club replaced two town houses next door to the Cutts-Madison House on Madison Place between 1909 and 1910. Lots at 740 and 744 Jackson Place, south of the Decatur House, became an eight-story office building in 1929. The site at 722 Jackson Place became the nine-story Brookings Institute headquarters in 1932, and 726 Jackson Place became an eight-story building owned by the International Bank in the mid-1930s. A five-story headquarters was built at 718 Jackson Place in 1937 for the Congress of Industrial Organizations, which eventually merged with the American Federation of Labor and built a larger headquarters in 1955 immediately north of St. John's Church.

To manage the change that was occurring throughout DC, Sen. James McMillan of Michigan chaired the US Senate Park Commission to create a comprehensive plan in 1902 on how the district could add to and develop parks in and around the city. The plan added new monuments, museums, and cultural attractions along the Mall and restored L'Enfant's city plan to its former prominence. The "McMillan Plan" also suggested that Lafayette Square become the location for new cabinet-level government office buildings, to be influenced by Classical Greek and Roman architectural sources. This was suggested in part to clear away the "outdated" Victorian buildings. It also would create a backdrop against which the commission sought to renew the democratic ideals of the country's founding fathers, who established the government modeled on Greek and Roman principles. While the McMillan Plan was not formally adopted by the US government, it formed the ideological foundation on which the Commission of Fine Arts would base its decisions concerning the square.

The government quietly began buying lots east and west of the square in 1930 to demolish structures in order to construct new government office buildings. A variety of schemes were developed for the new buildings. A plan was put forward and received Pres. John Kennedy's approval, but his wife interceded and campaigned to save the older buildings, advocating for a different approach. The firm John Carl Warnecke and Associates provided one such alternative by inserting new buildings behind or next to the older ones, using details and materials similar to and harmonious with the old. Today, this approach is seen as good contextual urban design, but in the 1960s, Jack Warnecke was chastised for his methodology.

Nearly 50 years have passed since the threat of demolition loomed over the square. Many people worked to save the historic buildings, but the intervention and determination of First Lady Jacqueline Kennedy made all the difference in saving the square's residential and historic character.

One

LAFAYETTE PARK

Before Lafayette Park became a stylish residential neighborhood, the park was part of a farm settled in 1685. By the late 1700s, the park had become an apple orchard with a family graveyard in the park's southwesterly corner. In 1792, the land was staked out as part of the grounds for the President's House, and it became filled with brick kilns, lime pits, and small huts to house the workers building the White House.

In the late 18th and early 19th centuries, the park's site was a rough, undefined parcel of land that served myriad uses. The northern edge of Lafayette Park was used as a straight racetrack leading west to the Potomac River (near the site of today's Watergate Hotel) and back. The site's undergrowth of scrub brush likely served for grazing. Anecdotal accounts mention the site's use as a zoo, a slave market, and an encampment for soldiers during the War of 1812 and the Civil War; however, sources for these uses have been elusive. The site's proximity to the Executive Mansion led to its use for political celebrations, and it later became the site for political demonstrations and protests.

Pierre L'Enfant thought the neighborhood surrounding the park would become home to foreign embassies, but it soon became one of the city's most fashionable 19th-century residential areas until a variety of governmental and commercial offices began to occupy the residences in the 20th century. Preserved today, the residential-scaled neighborhood nearly became a monolithic government office enclave in the 1960s.

While much national history has taken place within the park, it is also the site of local human-interest stories. The park has been the location of many accidents, affairs, drug busts, a murder, robberies, stabbings, suicides, and romantic liaisons. One such romantic couple overstayed its welcome in the park and was locked in after hours. A passerby heard the persons' calls for help and returned shortly with the needed ladder to scale the fence. Much to the couple's surprise, their rescuer was none other than Pres. Abraham Lincoln. The president had heard their cries for help while he was walking to the nearby War Department telegraph office.

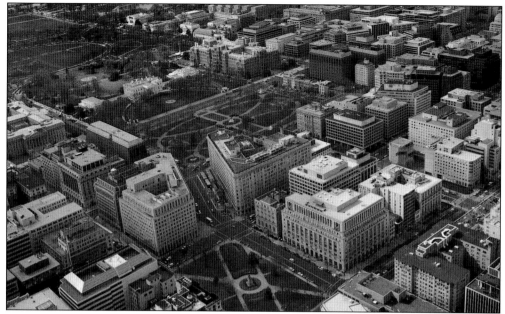

Taken sometime after 1990, this southeast-facing photograph of Lafayette Square clearly depicts its location, north of the White House grounds and connected to McPherson Square via Vermont Avenue. Due to its proximity to the White House, and because of camping restrictions in Lafayette Square, Occupy DC established its encampment in McPherson Square on October 1, 2011. US Park Police officers evicted the group on February 4, 2012, citing no-camping statutes.

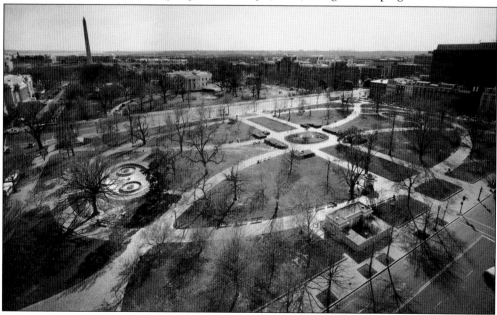

Lafayette Park's layout today dates from a 1969 renovation that was implemented in seven months from designs by architect John Carl Warnecke. The redevelopment, part of Lady Bird Johnson's City Beautification program, included two double fountains in oval pools, more benches, built-in tables for playing chess or checkers, and elliptical walkways that used brick identical to the new buildings on the east and west sides of the square.

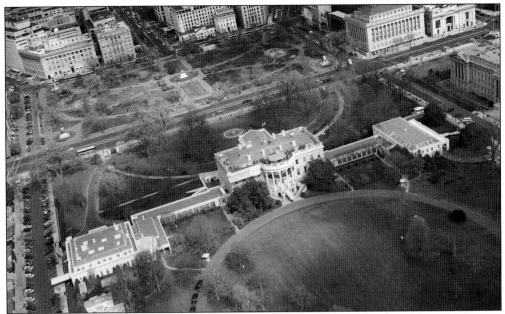

Lafayette Park is historically linked to the White House grounds. Between 1792 and 1800, huts were constructed in the park to house workers building the President's House. Brick kilns and lime pits used to make mortar were also in the park. In 1804, Pres. Thomas Jefferson ordered Pennsylvania Avenue to be cut through the grounds of President's Park to make the White House grounds less royal in appearance.

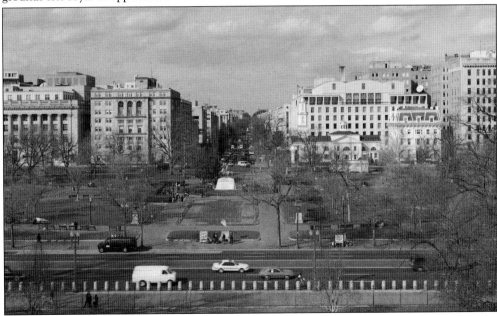

In front of the White House, Pennsylvania Avenue was once a major thoroughfare for traffic, but it was closed to vehicles after the Oklahoma City bombing in 1995. This change became permanent after the events of September 11, 2001. Through it all, William Thomas and Concepcion Picciotto have staged an antinuclear peace vigil in Lafayette Park since 1981, thought to be the longest-running such vigil in US history.

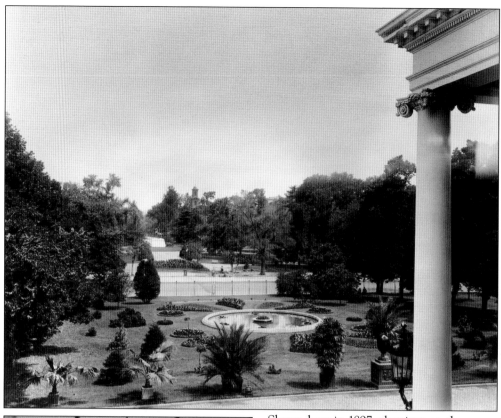

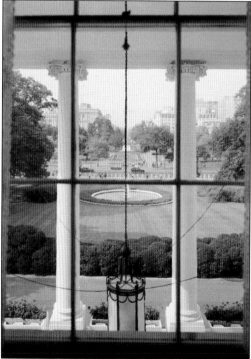

Shown here in 1897, plantings on the White House north lawns matched those in Lafayette Square. In the 1870s, Pres. Ulysses S. Grant installed a round pool and picturesque planting beds on the north lawn to match those planted in Lafayette Square in 1872 and designed in 1851 by landscape architect Andrew Jackson Downing.

The White House north grounds and Lafayette Park are seen here from a second-floor closet window under the North Portico. The current round pool is larger than the one installed for President Grant in the 1870s. Many of the existing trees date to 1878–1880, when hundreds of trees were planted during the Rutherford B. Hayes administration. This act inaugurated the tradition of planting commemorative trees on the White House grounds.

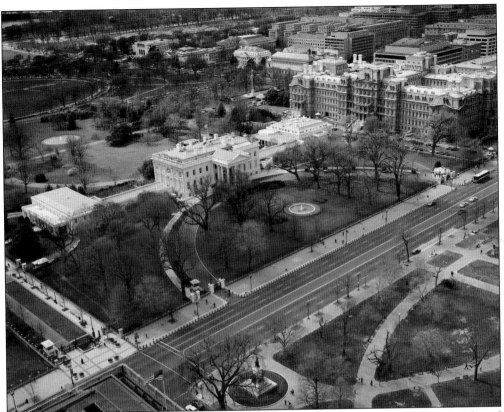

Andrew Jackson Downing's picturesque 1851 design was finally implemented in 1872, but it lasted only 64 years. Between 1936 and 1937, Works Progress Administration (WPA) laborers modified the park's landscape following Neoclassical patterns. The 1969 redesign retained the Neoclassical geometry, such as the center walkways and lawn panels (middle right). This aerial photograph shows how the White House's circular north drive visually relates to the park's geometry.

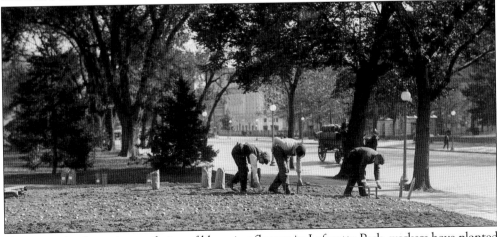

To prepare for the spring profusion of blooming flowers in Lafayette Park, workers have planted thousands of bulbs in the fall for over a century. Here, workers are planting in 1914. Other past attractions in the park have included prairie dogs and deer, which were presented as gifts to President Grant in 1876 and displayed within fenced enclosures on the grounds of the park.

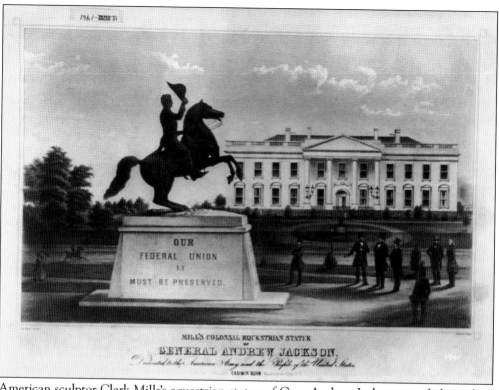

American sculptor Clark Mills's equestrian statue of Gen. Andrew Jackson was dedicated on January 8, 1853, the 38th anniversary of the Battle of New Orleans. The event attracted a crowd of 15,000. Famous orator and senator Stephen A. Douglas was the keynote speaker. Also visible in this image, across the street, is the Thomas Jefferson statue. Installed by Pres. James Polk, it stood from 1848 to 1875 and was the only presidential monument to stand on White House grounds.

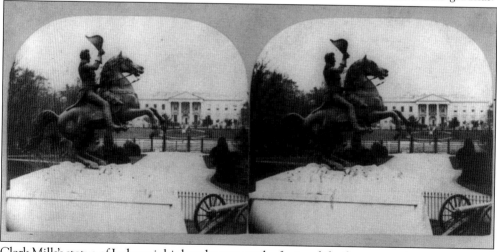

Clark Mills's statue of Jackson is his best-known work of art and the first equestrian statue erected in the United States. Mills made three copies of his statue, located in Jacksonville, Florida; New Orleans, Louisiana; and Nashville, Tennessee. The novelty of his statue was so great, the crowd present at its dedication doubted its two-legged stability. Mills threw himself at his own statue to silence the doubters. It did not budge.

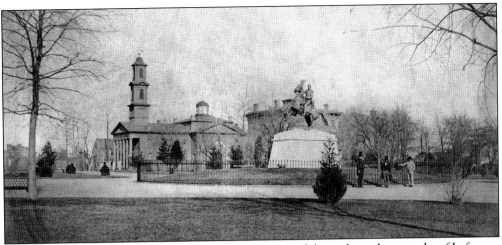

The above photograph, taken around 1857, may be one of the earliest photographs of Lafayette Park. It depicts a very young landscape only four years after the park's sculpture of Jackson was dedicated. In the background are St. John's Church (left of statue) and Ashburton House (behind statue). To fabricate the statue of Jackson, Clark Mills set up a studio and foundry on Fifteenth Street in 1849. Mills bought a Thoroughbred horse and trained it to rear and stay in that position so he could capture its stance. He then devised a way to balance the sculpture's weight on the horse's slender hind legs. Mills made six castings before the final casting was completed in December 1852. The entire statue was cast in ten pieces, four of the horse and six of Jackson, for a total weight of 15 tons.

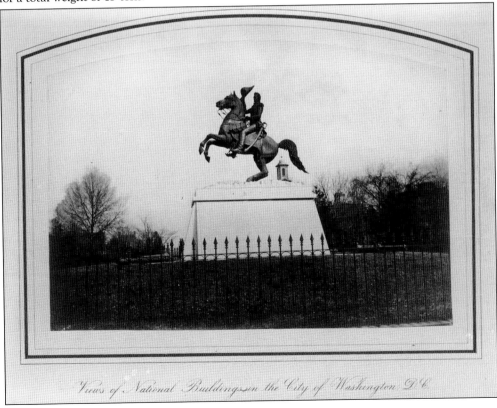

Views of National Buildings in the City of Washington, D.C.

At 14 feet tall, the statue of Andrew Jackson is a third larger than life. At its base are four rare cannons captured by Jackson in Pensacola, Florida. They were cast in Barcelona, Spain, and are named El Aristeo (1773), El Apolo (1773), El Witiza (1748), and El Egica (1748), after Greek gods and Visigoth kings. The cannons sat on the ground for over 13 years before being mounted on wooden carriages.

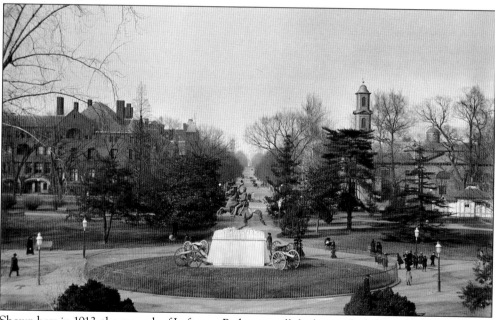

Shown here in 1913, the grounds of Lafayette Park were still the heart of a fashionable, cosmopolitan neighborhood of politicians, cabinet members, businessmen, authors, and philanthropists. Their proximity to the White House was seen as essential to their status. This would begin to change within 20 years, as residences shifted toward commercial and government interests. The walks, lampposts, and watchman's lodge (far right) date from 1872.

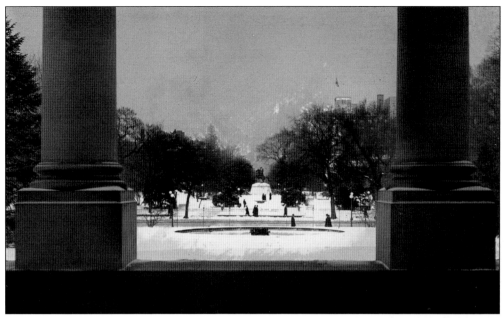

Viewed from the White House North Portico, this 1923 winter scene of Lafayette Park shows electric lamps dating from 1887. The lamps replaced gas lamps in an effort to curb criminal and "immoral" acts after dark. A high iron fence once surrounded the park, but it was removed in May 1890 and donated to the Gettysburg Battlefield Memorial Association by a joint congressional resolution through the efforts of former neighborhood resident and veteran Daniel Sickles.

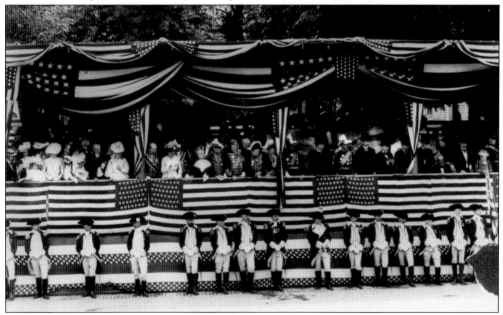

The third sculpture added to the park depicted Maj. Gen. Comte Jean de Rochambeau, to commemorate his command of French troops vital to the 1781 victory at Yorktown during the American Revolution. It was created by the deaf French sculptor Fernand Hamar. The May 24, 1902, dedication was a notable American-Franco celebration attended by Pres. Theodore Roosevelt and 2,000 official guests in three reviewing stands, along with thousands of onlookers.

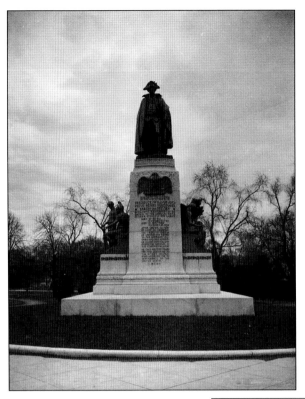

In the park's northwest corner is the 1910 sculpture of Gen. Baron Friedrich Wilhelm von Steuben by Albert Jaegers. Known as the Father of Military Instruction, Steuben is shown wearing the uniform of a major general of the Continental army, heavily cloaked to ward off the winter cold at Valley Forge, Pennsylvania. His Prussian army experience provided the training and discipline needed to organize the American soldiers into an army.

Rochambeau, in the park's southwest corner, is shown directing his troops and wearing the French uniform as the king's official representative. Below him, Lady Liberty raises two flags in her left hand, symbolizing unity between France and America. With a sword in her right hand, she prepares to defend an embattled eagle symbolizing America. The eagle's right talon grasps a shield with 13 stars for the 13 colonies. With its left talon, the eagle fends off aggressors.

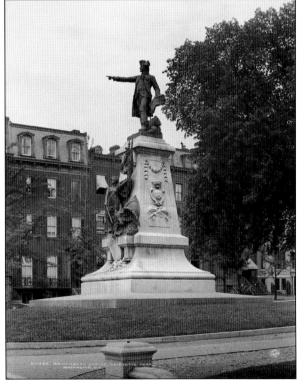

In the park's northeast corner is the 1910 sculpture of Gen. Thaddeus Kosciuszko by Antoni Popiel. Kosciuszko's skill in building defenses in strategic locations was a key factor in America's success in the Revolutionary War. Wearing the Continental army's general uniform, Kosciuszko holds a map of the fortifications of Saratoga, New York. On the base on the far side, not visible here, is an eagle fighting with a snake, representing democracy overcoming tyranny.

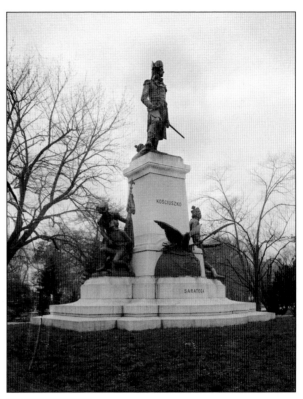

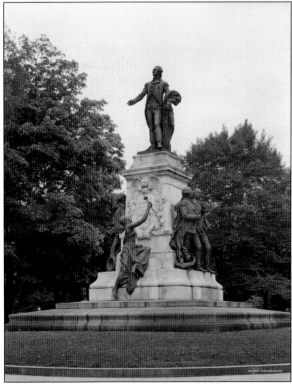

The second sculpture added to the park is the 1891 statue of Gen. Marquis de Lafayette, located in the southeast corner. It was made by Jean Alexandre Joseph Falguière and Marius Jean Antonin Mercié. Lafayette's financial support to the Americans came at a critical time in the Revolutionary War, and he served under Gen. George Washington. The female figure at the base, signifying America, imploringly lifts a sword to Lafayette for his support.

19

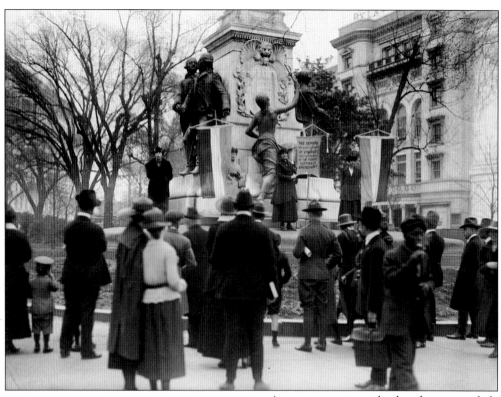

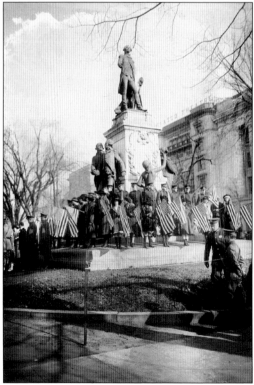

As women nationwide played an expanded role in 1918 for the war mobilization effort, National Woman's Party (NWP) members continued their vocal and visible campaign for the right to vote through events at the statue of General Lafayette. They connected with the female figure symbolizing America pleading for support, and they criticized Pres. Woodrow Wilson's fight for democracy in Europe when he would not support women's participation in democracy at home.

In 1921, the American Foreign Legion sponsored a 10,000-mile tour throughout America to show appreciation to the French supreme commander of the allied armies, Marshal Ferdinand Foch, who accepted Germany's surrender in World War I. On November 22, 1921, Foch arrived in Washington, DC, for ceremonies at the Lafayette statue. Howard Fisk, commander of the George Washington Post of the American Legion, pinned a badge on Foch as its newest member.

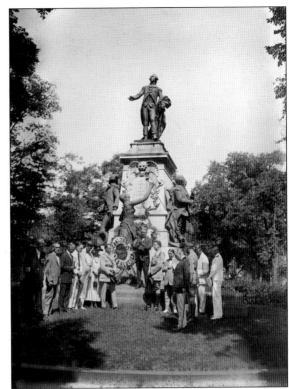

Throughout much of the 20th century, the US Departments of State and War, various embassies, and other organizations held wreath-laying commemorative ceremonies at the statues in Lafayette Park. These two photographs show such events at the statue of Gen. Marquis de Lafayette. At right, on September 6, 1922, members of the Sons of the American Revolution and French Embassy diplomats honor Lafayette's memory by placing a wreath at the foot of the French hero's statue on the 165th anniversary of his birth. In the photograph below, American government officials, French diplomats, and a military color guard celebrate the 167th anniversary of Lafayette's birth on September 6, 1924.

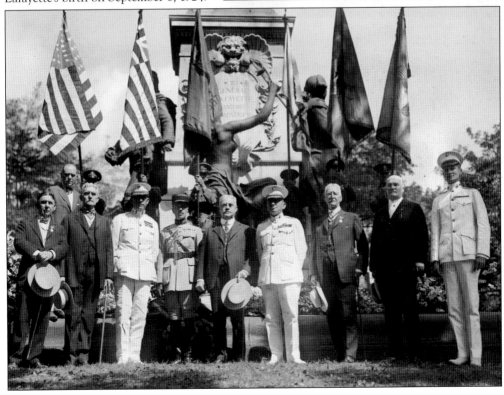

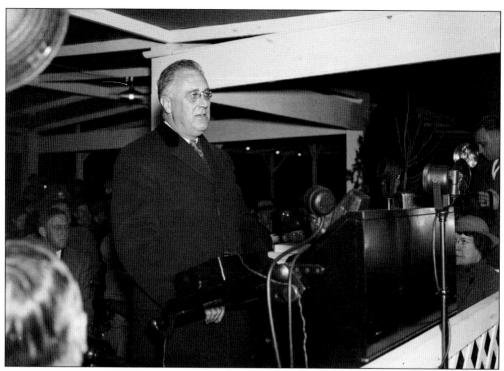

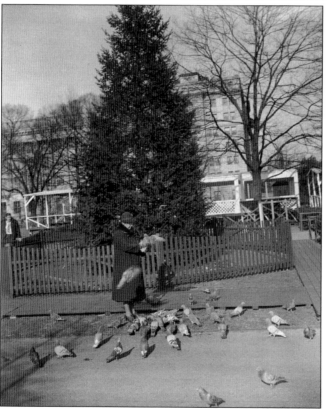

Shown above in 1934, Pres. Franklin Roosevelt prepares to push the button on the "switch box" to illuminate the National Christmas Tree, part of a tradition that Pres. Calvin Coolidge started in 1923. During Roosevelt's term as president, the National Christmas Tree was located in Lafayette Park. The tree was not lit between 1942 and 1944 due to World War II. Presidents and their families still participate in lighting the National Christmas Tree, but the ceremony now occurs in the southern half of President's Park, on the Ellipse, south of the White House grounds. A photograph of the tree in 1938 (left) shows the stands built to accommodate and protect participants from possible inclement weather. Mable White, a local resident, feeds pigeons in the park.

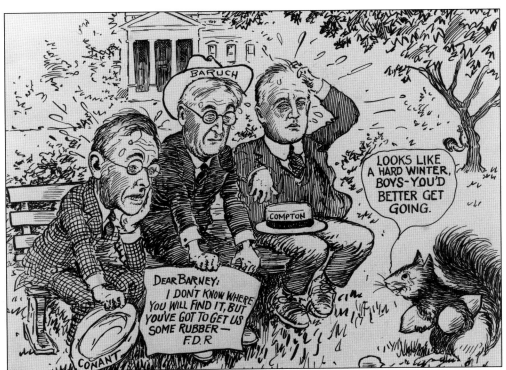

Bernard Baruch served as an economic and political advisor during both world wars to six presidents. He became so well known for sitting in the park while waiting to meet with the president, he was dubbed "the Park Bench Statesman." Baruch once received a letter addressed to him at his bench. A commemorative bench and bronze plaque, located northwest of the Jackson statue, were dedicated on August 16, 1960, Baruch's 90th birthday. The cartoon shown above refers to the committee formed by Baruch (center), Harvard president James Conant (left), and MIT president Karl Compton to solve the rubber shortage during World War II, when Japan controlled over 90 percent of the world's crude rubber sources. From 1941 to 1946, the marquee lights of the Belasco Theatre (below) were restored when the venue served as a Stage Door Canteen to entertain servicemen and servicewomen during World War II.

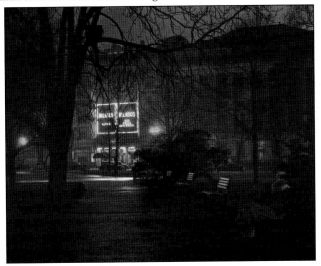

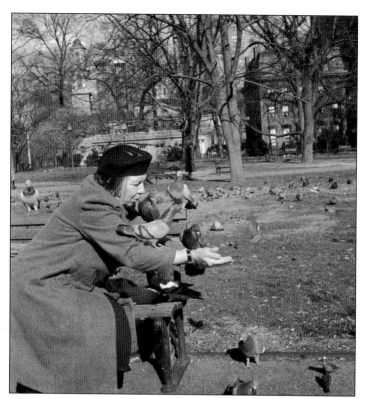

In 1942, the National Park Service completed a tree survey in the park and published a pamphlet chronicling the wide variety of trees. The pamphlet was then made available to the steadily increasing crowds of office workers within the park during lunchtime. These 1943 photographs show Mabel White feeding pigeons within Lafayette Park. An everyday sight, White fed the park's birds for over 20 years. Visible in the background are the park's lodge (left), built in 1914, and the Ashurton house (right), seen before the stucco and stone were painted in shades of yellow and white.

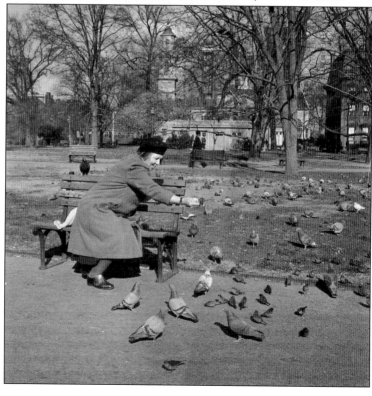

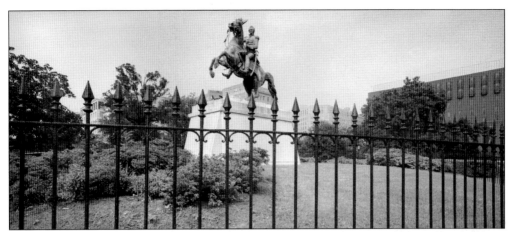

The square and its contents have undergone different arrangements and classifications throughout its history, but they are recognized as important. In 1964, the Andrew Jackson statue was listed as a DC historic site. In 1970, the square and surrounding structures were designated a National Historic Landmark. In 1978, the four Revolutionary War statues were included as contributing monuments in the American Revolution Statuary listing in the National Register of Historic Places.

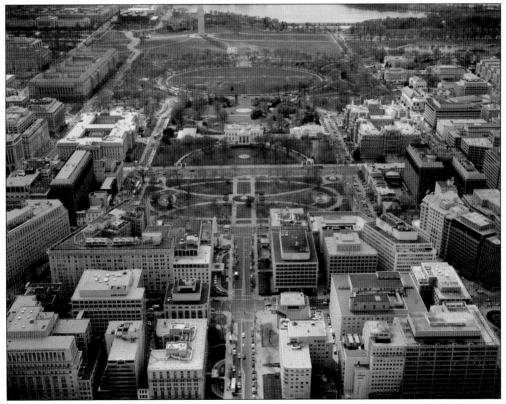

This 1990s south-facing photograph down Sixteenth Street to Lafayette Square shows how the new federal office buildings on Madison (left) and Jackson Places were set behind the historic town houses and mimicked mansard roofs and oriel windows on nearby structures. The high-rises were constructed first, followed by the infill town houses. Savings realized while building the high-rises allowed for exterior restoration and interior renovation of the historic town houses at the project's end.

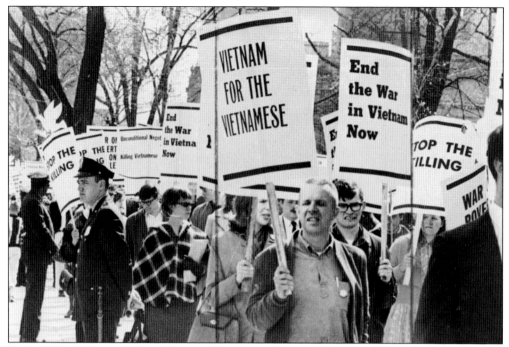

In the 1960s, Lafayette Park was the site of important demonstrations by groups exercising their First Amendment rights. On November 27, 1965, members of Students for a Democratic Society (SDS) participated in a major antiwar demonstration across from the White House (above), picketing against US policies in Vietnam. During the demonstration, SDS president Carl Oglesby gave a speech that received substantial press coverage, increasing the organization's national prominence. Following the assassination of Martin Luther King on April 4, 1968, demonstrators (below) peacefully marched in Lafayette Park the next day. Unfortunately, riots erupted elsewhere in the city, lasting for five days and damaging over 1,200 buildings, including 900 stores. In addition, 12 persons died, 1,093 were injured, and 6,100 were arrested. Similar civil disorder occurred in over 110 US cities, with Chicago, Baltimore, and Washington the hardest hit.

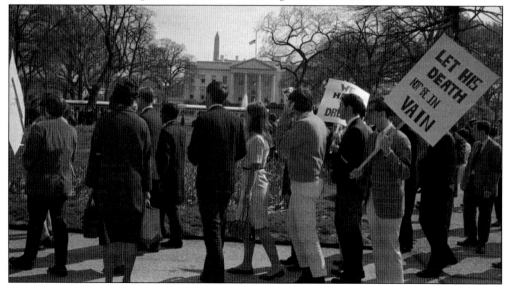

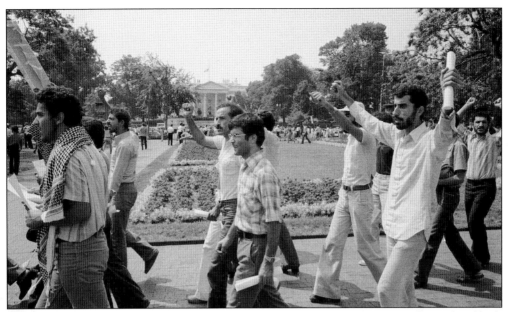

Opinions about political and military matters tend to be varied and can strike unpopular chords with the public. The history of demonstrations in Lafayette Park reflects such positions. On August 8, 1980, Middle Eastern students (above) marched in the park in support of the Ayatollah Khomeini. US Park Police kept hecklers, angry because of the Tehran hostage crisis, at bay. In 1919, women opposing US involvement in World War I protested at the park and at the White House (below). Their signs reference David Lloyd George, Great Britain's prime minister and leader of the wartime coalition during World War I. At the time, anyone protesting against the president was seen as unpatriotic and were therefore heckled and bullied.

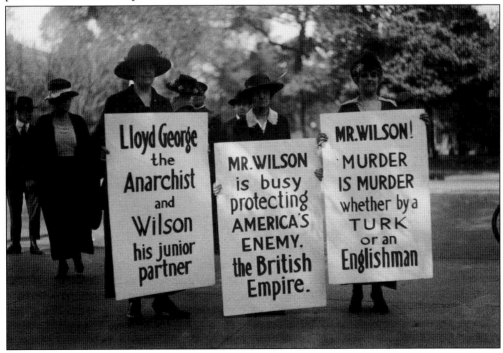

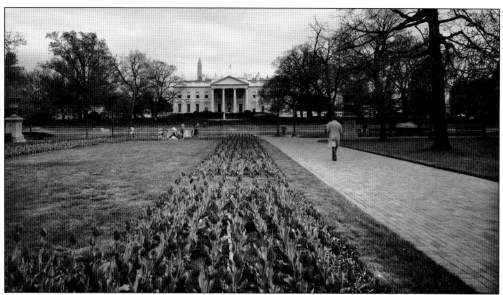

The planting beds in Lafayette Park and on the White House north lawn, managed by the National Park Service, complement one another and visually connect the two parcels that flank Pennsylvania Avenue. To maintain a parklike appearance and minimize demonstration signs, the National Park Service keeps tight control on the types and sizes of protest signs so that they do not block views or overwhelm the park.

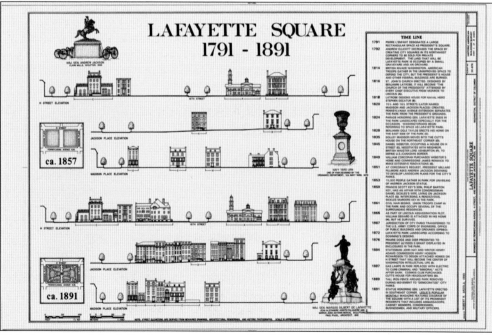

This drawing and the following two were completed by a team of architects and historians to document four periods of time in the history of Lafayette Square and its surrounding buildings. The documentation was compiled in 1991 for the Historic American Buildings Survey, the nation's first federal preservation program. Begun in 1933, its goal is to document America's architectural heritage. (Courtesy of Historic American Buildings Survey.)

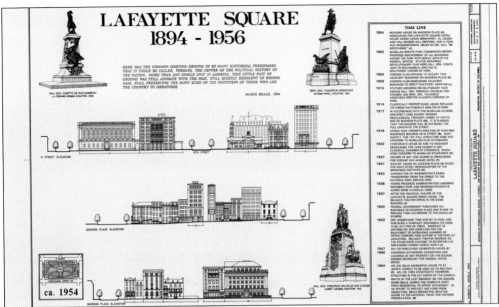

In 1902, the McMillan Senate Commission recommended the redevelopment of Lafayette Square by constructing monumentally scaled, Neoclassical cabinet office buildings facing the park. In 1930, Congress authorized acquisition of land around the square. In 1957, a commission initiated by Pres. Dwight Eisenhower recommended plans to demolish the buildings around the square to construct new federal office buildings on the east and west sides. This plan sparked a public outcry and corresponding legislation to designate several properties as landmarks. In 1962, First Lady Jacqueline Kennedy intervened to ask that the plans retain the historic buildings and the neighborhood's residential character. Architect John Carl Warnecke developed such a plan, putting the new buildings behind the older ones, using similar materials and forms. As a result, the prior firms' designs were replaced by Warnecke's proposal, which was constructed over five years. (Courtesy of Historic American Buildings Survey.)

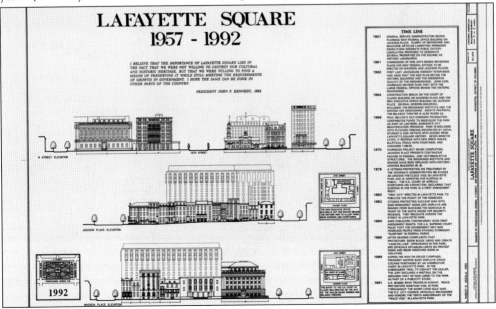

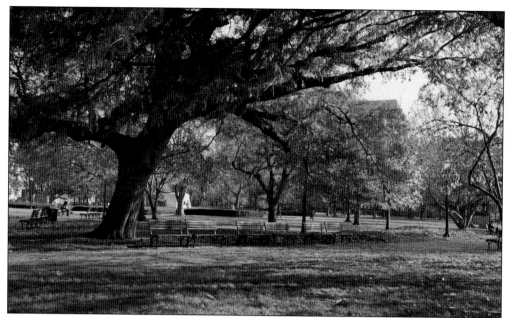

With seven acres of landscaped grounds, Lafayette Park is bounded on the north by H Street, on the east by Madison Place, on the south by Pennsylvania Avenue, and on the west by Jackson Place. This 2010 photograph captures a majestic willow oak with its lacy-thin leaves in the southwest corner of the park. The tree likely dates to the park's redesign and replanting in 1936.

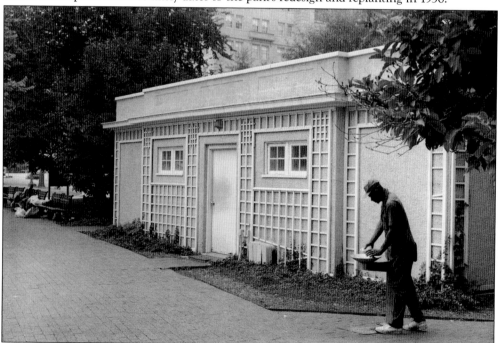

The only structure within Lafayette Park is the "watchman's lodge." Managed by the US National Park Service, it was built in 1914 in a Neoclassical style. It replaced an earlier Victorian structure in the same location. The original building served as a comfort station and restroom for visitors, as well as a shelter for the gardener and watchman of the park.

Two

JACKSON PLACE NW

Jackson Place had humble beginnings. It started as a gravel carriageway around the western side of President's Park, and it was first named Sixteenth and a Half Street in 1819. It received its current name in 1859, following the 1853 dedication of the Andrew Jackson statue in the park.

Undeveloped parcels on the west side of Jackson Place were initially a single lot, owned by the Decatur family. In 1819, the Decaturs sold the first parcel to Dr. Thomas Ewell, Navy surgeon, to build a house in the middle of the block, where 722 Jackson Place is located today. In 1860, three more parcels were sold to build town houses at 700, 704, and 708 at the south end of Jackson Place. The three parcels between the southern town houses and Ewell's House were developed after the Civil War (712 in 1869, 716 in 1868, and 718 in 1867), as were two more north of Ewell's House (730 and 736, built in 1869). The last two town houses to be built included 734 in 1878 and 726 in the 1880s.

Occupants of these Jackson Place homes made this a fashionable neighborhood in the late 19th century, resulting in some remarkable human-interest stories. On December 19, 1930, a three-week-old baby girl was left abandoned at 718 Jackson Place and given the name "Grace Lafayette." In two buildings were located unsuccessful presidential campaign headquarters: Republican James Blaine, at 736 Jackson Place, lost in 1884 to Grover Cleveland and Democrat Alfred Smith, at 726 Jackson Place, lost in 1928 to Herbert Hoover.

The building at 736 Jackson Place also hosted an important meeting between union leaders, coal-mine owners, and Pres. Theodore Roosevelt on October 3, 1902, during a national strike. The unions offered to arbitrate, but the owners refused. Roosevelt called them all together to hear their complaints. He secretly had his notes of the meeting published. The mine owners were shown snubbing the union's fair requests. The resulting public outrage against the owners compelled them to submit to arbitration by a presidential commission. President Roosevelt's action in settling the coal strike boosted his popularity and contributed to his decisive reelection in 1904.

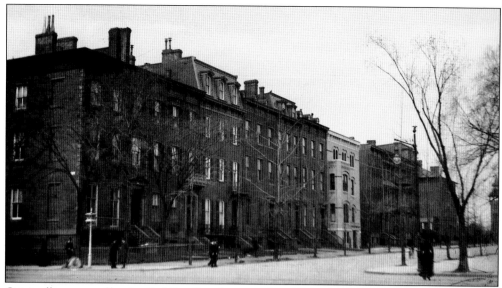

Originally a tract of land called Port Royal patented in 1685 to Samuel Davidson, Jackson Place was named in 1859. The federal government purchased the land in 1792 to form the District of Columbia. By 1803, the land was known as President's Park. In 1819, a gravel carriageway was laid out on the west side of the park and named Sixteenth and a Half Street. Shown above in a 1918 photograph, the Jackson Place town houses were completed by the 1880s. The two corner houses (below) date from 1860. In 1888, these two houses were occupied by the Bureau of Pan American Republics, the forerunner of the Pan American Union. Between 1910 and 1948, the houses served as the headquarters for the Carnegie Endowment for International Peace. The organization's goal was to "hasten the abolition of international war." (Below, courtesy of The Historical Society of Washington, DC, James M. Goode Collection.)

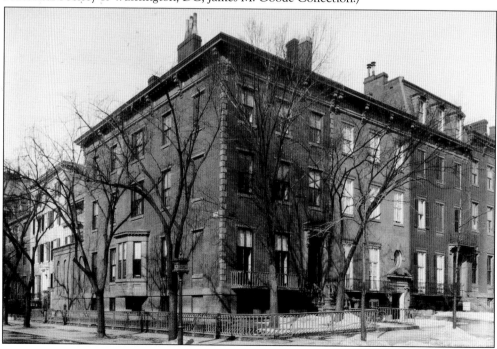

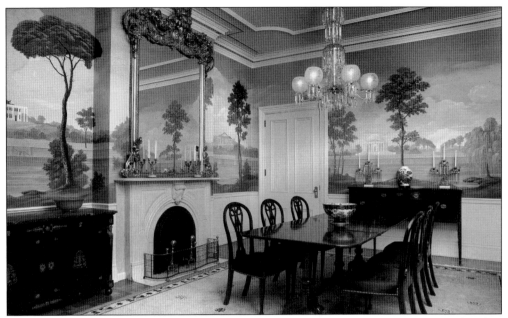

In 1948, the two corner houses were acquired by the US government and became part of the Blair House complex, which serves as the president's guesthouse, run by the Department of State. During the White House renovation, Pres. Harry Truman and his wife, Bess, occupied the buildings. The dining room (above) and the adjacent sitting room (below) at 700 Jackson Place were renovated and connected to Blair House between 1969 and 1970. Used for small, informal receptions or meetings today, the Blair House complex contains over 120 rooms. A full-time staff of 18 employees oversees numerous foreign policy–related meetings, luncheons, dinners, receptions, and visits by foreign leaders. These events underscore the buildings' diplomatic service for the president.

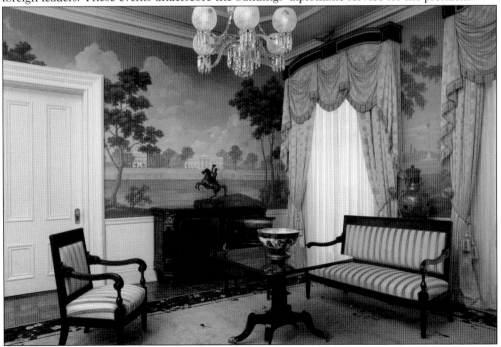

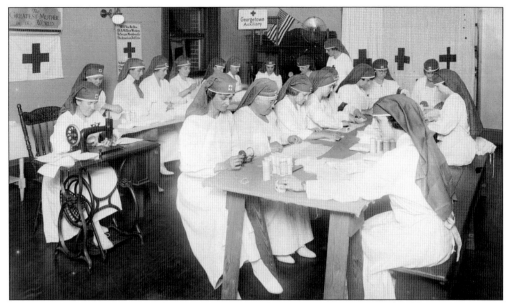

Architect John Carl Warnecke designed 726 Jackson Place as an infill building, to return a residential appearance to Lafayette Square. Constructed in 1967, it replaced an eight-story limestone structure owned by the International Bank, which had in turn replaced an 1880s building that had been the residence of John G. Parke, a Union general in the Civil War, an engineer with the Corps of Engineers, and a former superintendent at West Point. Between 1919 and 1926, the American Red Cross used the building as its chapter headquarters and office, as well as a location to comfort World War I veterans. These photographs depict Red Cross Teaching Center staff and volunteers making bandages and bundling clothing for the war effort. Later occupants of 726 Jackson Place included Waddy B. Wood, Department of Interior headquarters architect, and Philip Hubert Frohman, Washington National Cathedral architect.

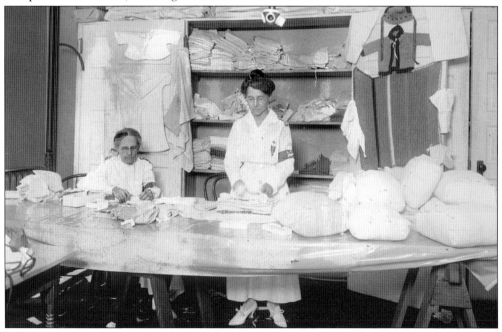

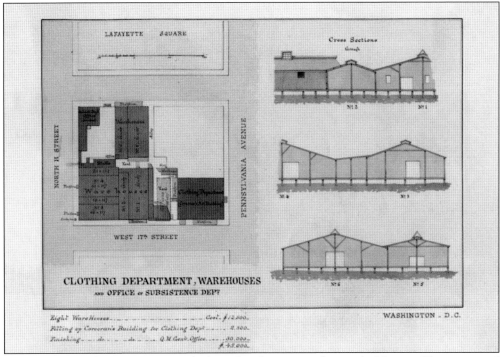

CLOTHING DEPARTMENT, WAREHOUSES
AND OFFICE OF SUBSISTENCE DEPT

WASHINGTON - D.C.

Between 1861 and 1865, temporary clothing distribution warehouses for Union soldiers occupied lots at 730 and 734 Jackson Place. The site plan, at left in this diagram, shows the temporary warehouse locations and how Decatur's corner house and Corcoran's art gallery were taken over for war uses. Not shown are private residences at 700, 704, 708, and 722 Jackson Place. The building cross-sections (right) are the only known images of these temporary buildings. (Courtesy of National Archives and Records Administration.)

The Decatur House is at right in this drawing, which also shows its two garden lots to the south. The drawing was made some time after 1895, when the house at 736 Jackson Place (left) was extensively remodeled by architects Carrère and Hastings, but before 1929, when an eight-story limestone building was erected between the two structures. Between June and October 1902, Pres. Theodore Roosevelt and his family lived at 736 while the White House underwent renovations.

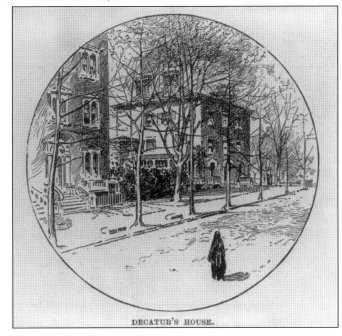

DECATUR'S HOUSE.

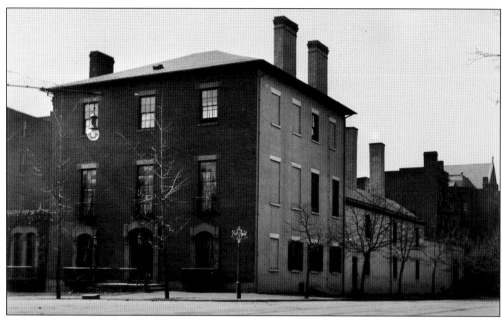

The first private residence on Lafayette Square was completed in 1820 for Commodore Stephen Decatur and his wife, Susan. It was designed by Benjamin Latrobe. Stephen Decatur died shortly after moving in, from injuries sustained in a duel. Susan Decatur moved out, but rented the house to a succession of French, Russian, and British ministers to the United States as well as two secretaries of state, Henry Clay and Edward Livingston. Creditors forced her to sell in 1836, when hotel and tavern owner John Gadsby bought the house. Shown around 1918 (above), the house sports the Victorian exterior renovations added by Edward Beale following his purchase of the house in 1872. By 1937 (below), the street's residential character dramatically changed following the 1929 arrival of a high-rise building, which became the headquarters of the National Grange of Patrons of Husbandry in 1947.

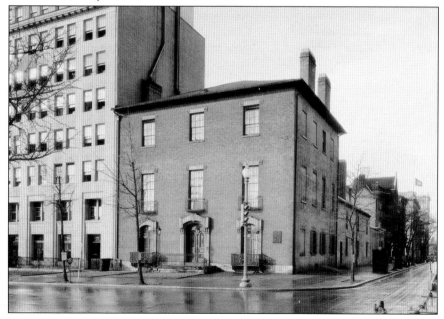

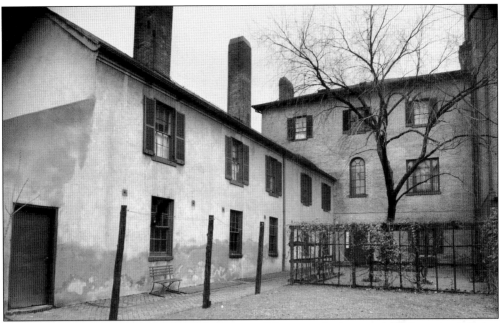

Shown in 1937, the stucco building behind Decatur House was built around 1836 to serve as living quarters for up to 21 people enslaved to the household of John and Providence Gadsby. Originally smaller, the building started 10 feet away from the residence and ended after the middle chimney. The building is notable as one of the last surviving examples of an urban slave quarters.

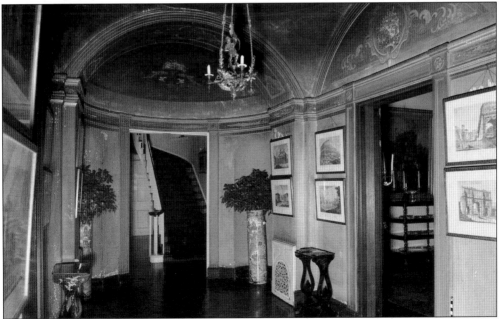

The ground-floor entrance hall of Decatur House, shown here in 1937, still retains the Victorian painted decoration from its 1872 remodeling following Edward Beale's purchase of the house from descendants of Providence Gadsby. Beale, a frontiersman, entrepreneur, and ambassador, became known for entertaining the Washington elite at his home. Before Beale acquired the property, it was used by the government as the Subsistence Bureau offices during the Civil War.

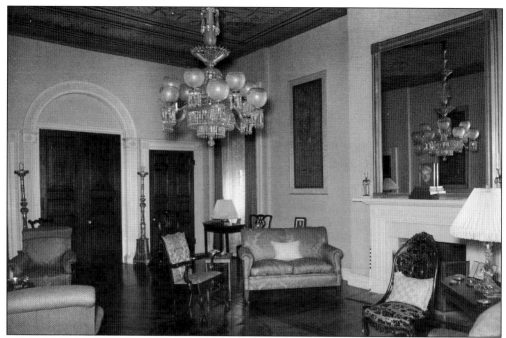

Following his parents' death, Truxton Beale inherited the home, moving into it in 1912 with his second wife, Marie. Truxton had served as ambassador to Persia, Greece, Romania, and Serbia, and he and Marie continued their family's tradition of high-style entertaining. They were well known for their parties, to which they invited many diplomats and Washington political insiders. Truxton died in 1936, but his widow survived him until 1956, when she was the last resident on the square. Shown in 1937 are the second-floor drawing room (above) and the music room (below).

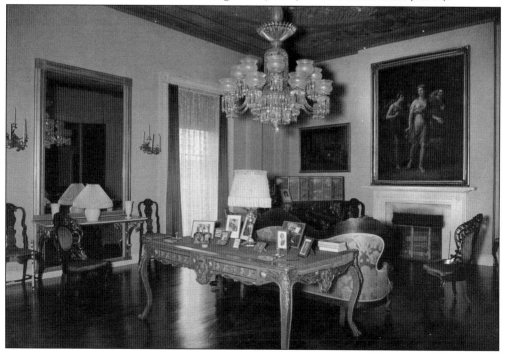

Government plans to demolish the town houses to construct modern office buildings led Marie Beale to bequeath the Decatur House in 1957 to the National Trust for Historic Preservation, to protect it from demolition and to preserve the neighborhood's residential character. As a result, design schemes for the new office buildings retained the Decatur House on the north corner, but included a copy at the south end of the block. The resulting infill construction and rehabilitation of historic town houses by 1971 (right) marked an important change in federal policy toward contextual urban design and appreciation and preservation of nonmonumental buildings. This contributed to the philosophical underpinning of the secretary of the interior's Standards for Rehabilitation. To retain the prominence of Decatur House (below), the infill town house next door was designed to be shorter, of dark brick, and slightly recessed.

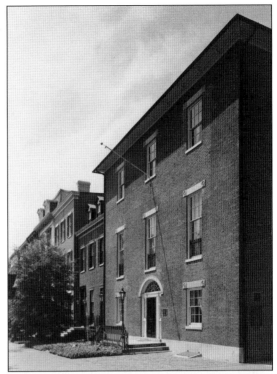

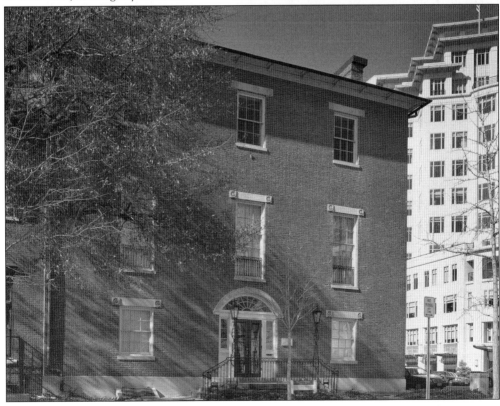

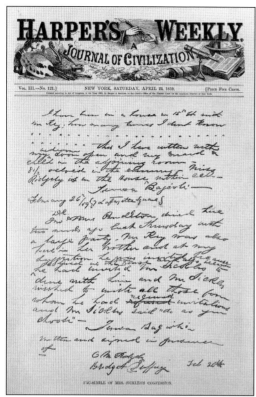

On February 26, 1859, New York congressman Daniel Sickles learned about a torrid affair between his young, beautiful wife, Teresa Sickles, and DC's district attorney, Phillip Barton Key, son of Francis Scott Key. Soon after, her handwritten confession (shown) was revealed during her husband's "trial of the century" for killing her lover. The confession states, in part, "I have been in a house in 15th Street with Mr. Key; how many times I don't know."

Upon investigation of his wife's infidelity, Daniel Sickles learned that she and Phillip Key had rented a house two blocks away for their trysts. As a signal that Key would be there, he would stand in the park, opposite Sickles's house, and wave a handkerchief. The day after learning of the affair, Sickles spied Key in the park waving a cloth. Enraged and armed, Sickles chased and shot an unarmed Key, killing him.

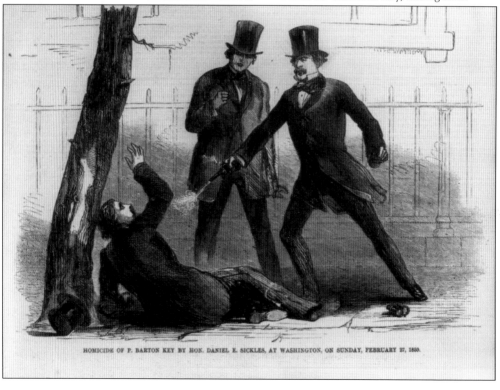

HOMICIDE OF P. BARTON KEY BY HON. DANIEL E. SICKLES, AT WASHINGTON, ON SUNDAY, FEBRUARY 27, 1859.

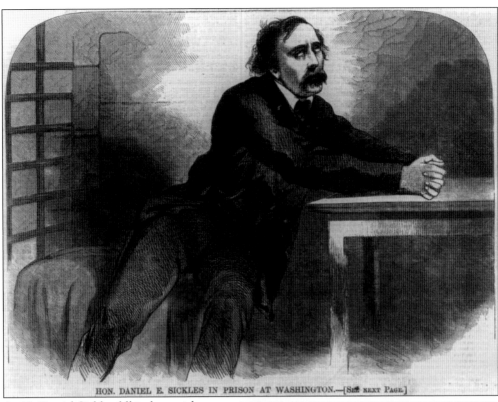

HON. DANIEL E. SICKLES IN PRISON AT WASHINGTON.—[See NEXT PAGE.]

At 33, Daniel Sickles fell in love with 15-year-old Teresa Bagioli, and he proposed marriage. Her parents, however, did not approve. The couple wed anyway in a civil ceremony, at which her family conceded with a church wedding. Sickles and Bagioli had a daughter seven months later. Scandalous details such as these made Sickles's murder trial a national sensation. While Sickles was a known womanizer, society viewed his wife's actions as unacceptable, and Sickles was acquitted of murder in the first example of the temporary insanity defense in the United States. Sickles (above) eventually forgave Teresa, which caused an outraged public to turn against him. Sickles continued public service as US minister to Spain following service as a Civil War Union general (right). He earned the Medal of Honor after losing his lower right leg during the Battle of Gettysburg.

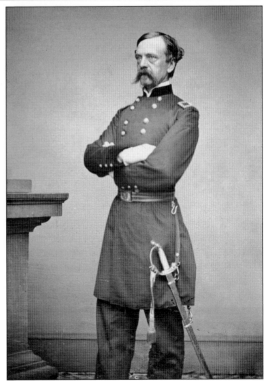

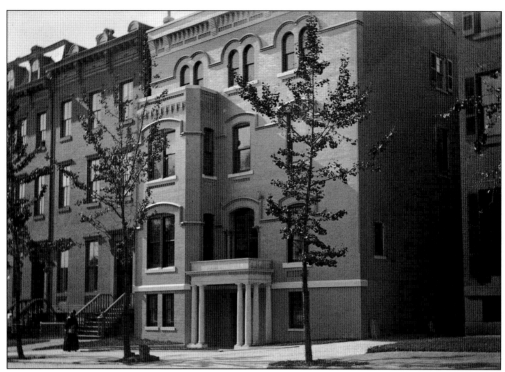

The second residence on the square, 722 Jackson Place (above), is notable for its famous residents. Built in 1819 for Navy surgeon Dr. Thomas Ewell, it was leased between 1824 and 1850 by three secretaries of the Navy, a secretary of war, two senators, and an attorney general. In 1850, the home was bought by Navy purser Francis Stockton, whose wife was Stephen Decatur's favorite niece. Upon Stockton's death, the house was leased to Daniel and Teresa Sickles. Between 1865 and 1918, occupants included a postmaster general; congressmen; secretaries of state and Navy; Brazilian, Chilean, and Spanish ambassadors; businessmen; and President Grant's vice president, Schuyler Colfax. In 1918, Alice Paul rented the house for the National Woman's Party (NWP) headquarters (below). In 1932, the Brookings Institute replaced the house with a nine-story limestone building.

Born a Quaker, Alice Paul was raised with the principle of equality of the sexes. This drove her to seek suffrage and equal rights for women and engendered in her acceptance of different religions. In March 1918, she permitted use of her headquarters for 93 persons who withdrew their membership in the First Church of Christ, Scientist to form the Third Church of Christ, Scientist in Washington, DC.

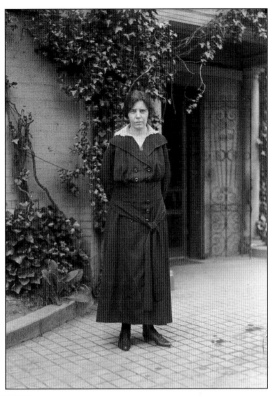

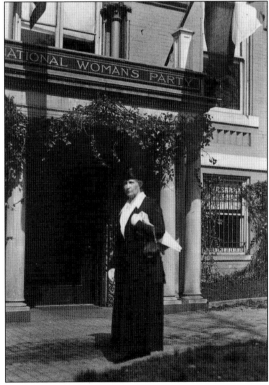

Sarah Colvin, of St. Paul, Minnesota, was state chairman of the NWP. She and her husband, Dr. A.R. Colvin, came to DC during World War I for his work at Fort McHenry. Trained as a nurse, she worked at the Red Cross headquarters nearby. A vocal NWP supporter, she was arrested in watch-fire demonstrations in January 1919 and sentenced to a pair of five-day terms at Occoquan Workhouse.

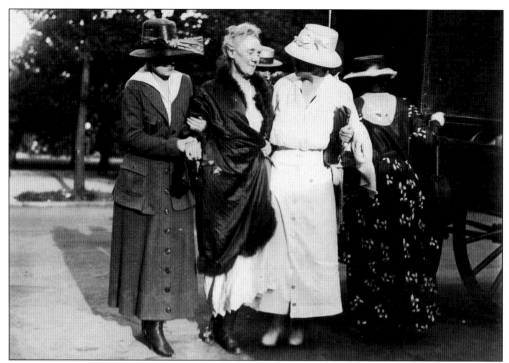

Shown following five days of hunger striking in jail, Dora Lewis is physically supported by Clara Louise Rowe (left) and Abby Scott Baker on her return to NWP headquarters in August 1918. From a prominent Philadelphia family, Lewis was among the outspoken hunger-striking suffragist prisoners who received some of the most brutal treatment from wardens at the district jail and the Occoquan Workhouse.

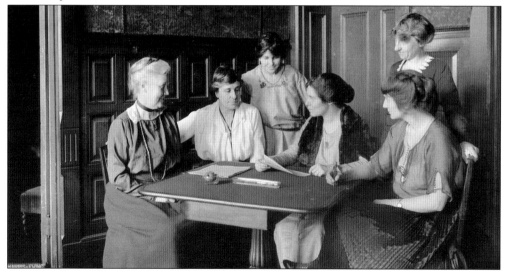

In 1918 and 1919, actions by the NWP in Washington, DC, yielded national press coverage, which increased the organization's membership throughout the United States and garnered sympathy for its cause. Shown here in a publicity photograph are, from left to right, Dora Lewis, Abby Scott Baker, Anita Pollitzer (standing), Alice Paul, Mabel Vernon (standing), and Florence Boeckel. The women are conferring over ratification of the 19th Amendment to the US Constitution.

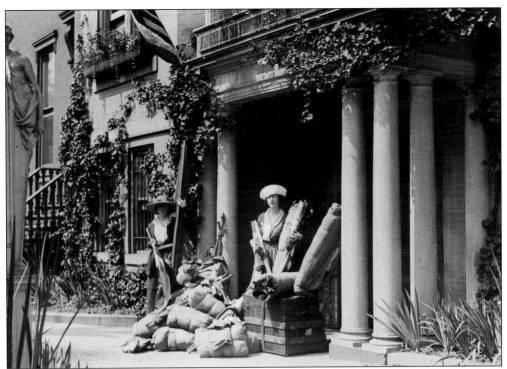

In early 1919, the NWP developed a 10,000-mile cross-country "Prison Special" tour, featuring the women who had been imprisoned at the Occoquan Workhouse and the district jail for peacefully demonstrating for the suffrage movement. The women spoke about the atrocities, such as beatings and forced feedings, they endured at the hands of the male and female prison wardens, all for the right to vote. Above and below, NWP volunteers are shown outside the headquarters on Jackson Place, holding the bundles of banners and prison uniforms as they prepare for the tour. The campaign tour was extremely effective, and it increased awareness of the suffrage amendment.

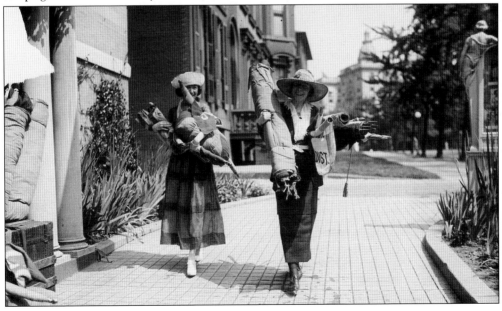

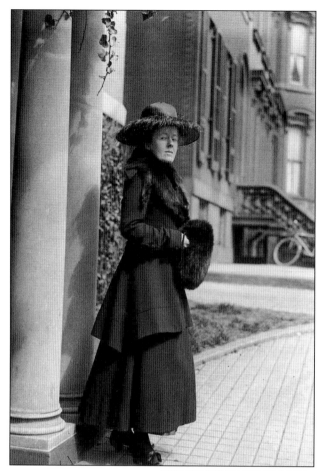

To pressure President Wilson for a constitutional amendment, the NWP started a new approach in January 1919. Members collected the president's speeches and burned them in urns outside public buildings. Through these displays, dubbed "Watch-fires of Freedom," the NWP sought to highlight the hypocrisy of Wilson's words, as he fought for democracy abroad while denying it at home. Predictably, this resulted in larger counterdemonstrations, more arrests, and publicity. Sally Hovey (pictured) participated in these demonstrations.

In May and June 1919, the House of Representatives and the Senate passed a suffrage amendment, sending the matter to each state for ratification. Needing 36 states to ratify the law, Alice Paul (third from left), national chairman of the NWP, created a Ratification Flag. A star was sewn onto the flag each time a state's governor signed the amendment following passage in their state legislature.

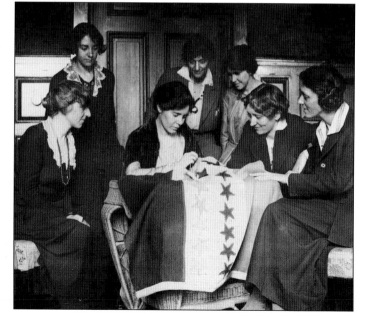

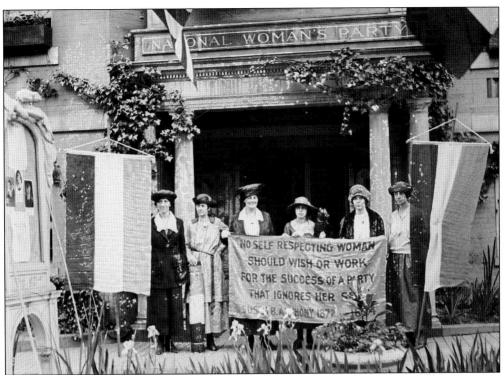

As the Democratic and Republican national conventions approached in June 1920, the Susan B. Anthony Amendment was not yet ratified by 36 states, so NWP delegations attended both conventions, lobbying states to support suffrage as part of their platform. Democrats agreed, but Republicans did not, resulting in NWP picketing their convention. Above, posing on Jackson Place with their Republican National Convention banners are, from left to right, the following: Sue White, Tennessee; Mrs. Benigna Green Kalb, Texas; Mrs. Joseph Rector, Ohio; Mary Dubrow, New Jersey; Alice Paul, DC; and Elizabeth Kalb, Texas. Their convention campaign was ultimately a success. On August 18, 1920, upon hearing that Tennessee had ratified the amendment, becoming the 36th state to do so, Alice Paul, seen on the balcony in the below photograph, unfurled the Ratification Flag from NWP headquarters on Jackson Place.

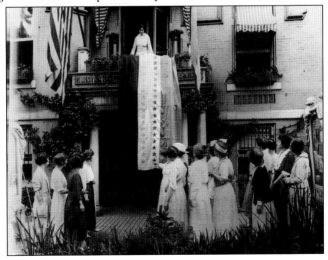

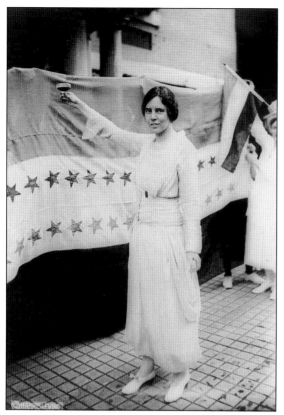

After celebrating passage of the 19th Amendment, Alice Paul (left) reflected on the decades of hard work by many women across the United States. Proud of their accomplishments, she was also pleased to see the work of her forbearers finally meet with success. However, Paul was unsure what role the NWP would continue to play in American politics. By January and February 1921, she and other NWP members decided to hold a conference to decide if the NWP would continue its work. Shown below in the NWP headquarters on Jackson Place are Alice Paul (far left), Elizabeth Kalb (far right), and two unidentified women issuing invitations to the conference. After the conference, the NWP continued its work for equal rights for women.

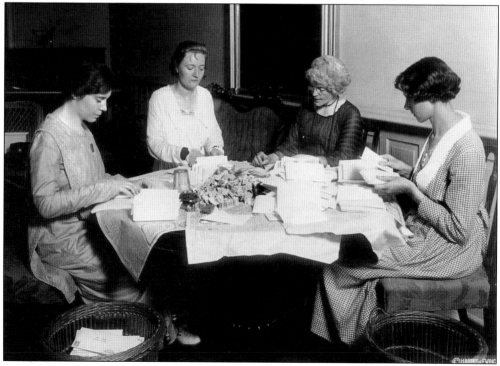

Following passage of the 19th Amendment, women returned to NWP headquarters throughout 1920–1921 to celebrate. Here, Edith Ainge of Jamestown, New York, displays her state flag. Ainge served five jail sentences for demonstrations, including 60 days in the Occoquan Workhouse for picketing in September 1917, 15 days in August 1918 for a Lafayette Square meeting, and three district jail terms in January 1919 for watch-fire demonstrations.

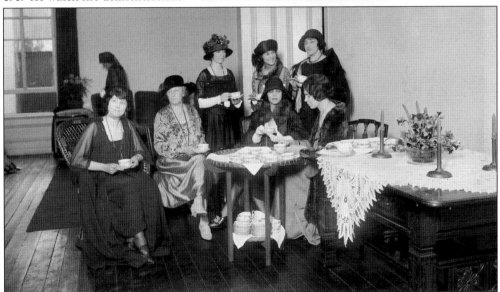

In 1923, Alice Paul authored a proposed Equal Rights Amendment (ERA) to the Constitution. Shown here is the tea party at NWP headquarters that Paul (seated, far right) sponsored in 1923 for famous actress Alice Brady (seated, second from right) to gain support for the ERA. It took until 1972 for passage by the Senate, but only 35 states ratified the measure, short of the required 38 by the time of its deadline.

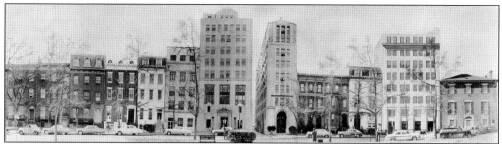

The c. 1957 photographic montage of structures on Jackson Place (above) shows nine buildings dating to the 19th century and four high-rises constructed in the 20th century. Several people are responsible for saving the historic buildings around the square. Charles Glover Jr., childhood resident at 734 (fourth from right), conceived of putting new buildings behind the old ones, which were sketched out by architect Grosvenor Chapman, who shared the sketch with William Walton, close friend and advisor to the Kennedys, who endorsed the concept. David Finley, Commission of Fine Arts chairman, opposed other design proposals and eventually approved the design by John Carl Warnecke, which was conceptually reminiscent of Chapman's sketch, although Warnecke had not seen it. The savior of Jackson Place, however, was undoubtedly First Lady Jacqueline Kennedy, whose determination put the project into action. The 1970 photograph below shows Jackson Place upon completion of the project.

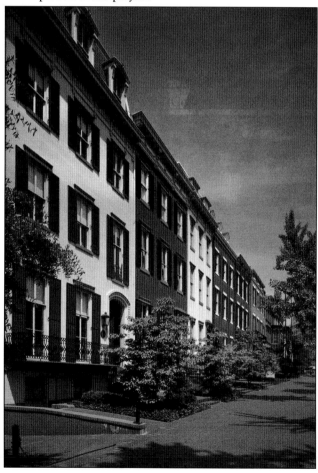

In this 2010 south-facing photograph, the bright-white facade of 716 Jackson Place stands out. Work completed in 2002 restored the Victorian facade (windows and doorway), removing Federal-style multipaned windows and ironwork installed in 1937 by Andrew Mellon. At that time, the building served as interim offices for the National Gallery of Art and its construction field office. The top-floor Federal-style dormers were retained, as that floor was Mellon's pied-à-terre when he was in town.

In 1906, a resident at 708 Jackson Place (third from left) had a cut-glass silver bottle stolen by Mary Lannan, a 32-year-old servant and notorious DC thief. In 1918, night watchman James King was killed in 712 Jackson Place (fourth from left) by William Clements, who arrived to stoke the building's fires. King pulled his gun's trigger, but it did not shoot. Clements fired his own gun, killing King in self-defense.

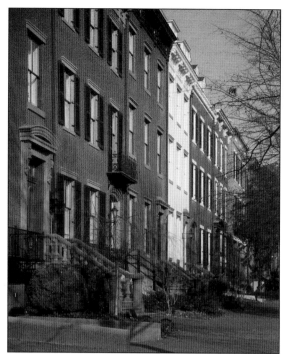

Based on historic photographs, the railings, shutters, windows, and metal balcony over the main entrance at 708 Jackson Place were restored in a project completed in 2002. Funded by the General Services Administration, work restored modifications made in 1882 to the 1860 house. To establish the restored railing as a product of work done in 2002, the intricate design was laser-cut from sheet metal, instead of its being re-created from cast iron.

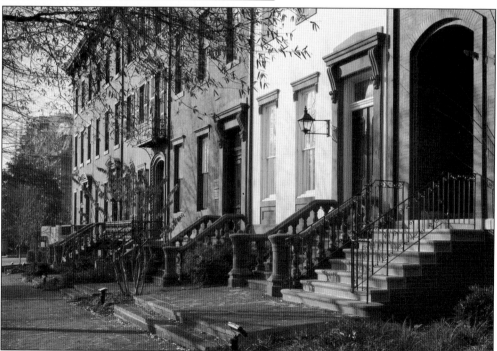

Part of the 2002 project, restoration of the brownstone stoops at 712 and 716 Jackson Place (second and third from right) was based on their 1860s design, as seen in historic photographs. When the stoop at 718 (right) was restored to its 1969 appearance, it was rediscovered that the stoop had initially been designed for stone balusters, but metal railings were installed as a cost-saving measure in 1969.

The building at 712 Jackson Place was restored to its appearance when constructed in 1869 for Adm. James Alden. He soon sold it to Henry and Clara Rathbone, who had the misfortune to share the theater box with president and Mary Todd Lincoln on the night of his assassination in 1865. The Rathbones lived in the house from 1869 to 1880, and their three children were born there. Henry Rathbone eventually went mad, killing his wife.

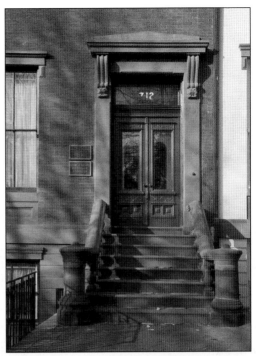

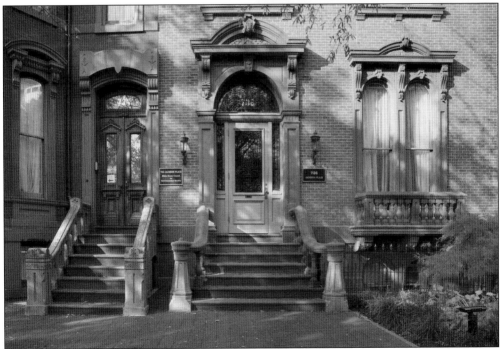

The structures at 734 (left) and 736 (right) Jackson Place date from 1878 and 1869, respectively. The "G" in the stoop's newel post at 734 is for Charles Carroll Glover, Washington banker, civic leader, and philanthropist. In July 1902, the War College Board leased 734 but found it too small. The board then moved next door to 736, which was also too small, so it erected a new building at the Washington Barracks.

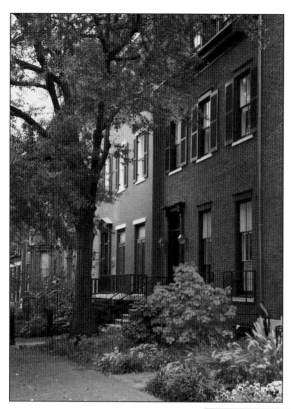

The buildings at 740 (center) and 744 (right) Jackson Place sit upon lots that were once a garden adjacent to the corner Decatur House. The eight-story limestone structure, erected in 1929, was razed in 1966 to construct these town houses, but only after the government agreed to trade the building for a new site on H Street behind Decatur House, along with $360,000 toward construction of a new building for its owners.

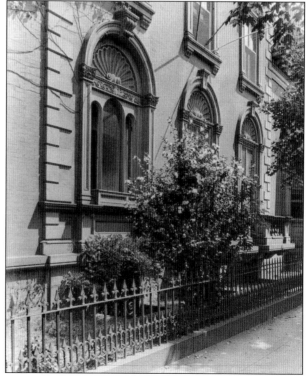

Shown in this 1900 photograph are the 1849 Italianate features that architect James Renwick added to William Corcoran's H Street house, introducing the style to the city for the first time. The house was built in 1828 as a Federal-style residence for prominent DC district attorney Thomas Swann. Living in the home from 1841 to 1848 was Daniel Webster, secretary of state in the Harrison, Tyler, and Fillmore administrations. Corcoran bought it after Webster's death.

Three

H STREET NW

H Street is a major east-west thoroughfare in Washington, DC. Initially an old ferry road that began at the Potomac River to the west, the street now passes eastward through the Foggy Bottom and George Washington University neighborhoods, skirts the northern boundary of Lafayette Park, passes through the Chinatown and the near Northeast neighborhoods, then finally connects with Benning Road to cross the Anacostia River on the east.

The first building erected on H Street bordering Lafayette Square was St. John's Episcopal Church, constructed between 1815 and 1816. With additions in the 1820s and 1890s to modify its original design, the church has remained a stalwart witness to the changes that have transpired over two centuries at the square.

At one time, residents along the square's northern boundary included government officials, diplomats, legislators, military officers, entrepreneurs, authors, clerics, and philanthropists. Today, all the residents are gone; the occupants of the hotel and office buildings that flank St. John's Episcopal Church are corporate and government staff that conduct the day-to-day business of national and international commerce.

The square's northern boundary features five structures, which provide a varied cross-section of America's architectural history. If the recommendations of the McMillan Plan from 1902 had been fulfilled, the square's northern boundary would have instead consisted of two imposing Neoclassical government office buildings, all the way from Connecticut Avenue to Vermont Avenue, separated only by Sixteenth Street in the middle. This nearly came to pass, as evidenced by the Neoclassical six-story headquarters for the US Chamber of Commerce that was built in 1922. To picture how planners in 1902 envisioned a future Lafayette Square, visualize a copy of the US Chamber of Commerce Building stretching eastward to Sixteenth Street and Vermont Avenue and then stretching southward to connect to the Department of Treasury Annex at the southern end of Madison Place. Businessmen intervened with commercial ventures, which resulted in the construction of the Hay-Adams Hotel and the Department of Veterans' Affairs headquarters. The by-product was the preservation of St. John's Episcopal Church, Ashburton House, and the houses at the northern end of Madison Place.

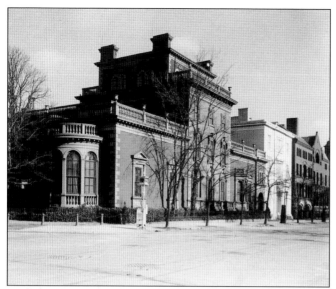

In 1824, the ferry road at Lafayette Square's northern boundary formally became H Street. It had served as a straight racetrack to the site of today's Watergate Hotel and back. Dominating the block between Connecticut Avenue and Sixteenth Street in 1900 were three residences: the Corcoran residence, built in 1828 and renovated in 1849; the Ritchie/Slidell House, built around 1840; and the Adams-Hay House, built in 1884. (Courtesy of the National Park Service, E.B. Thompson, Historic Negative Collection.)

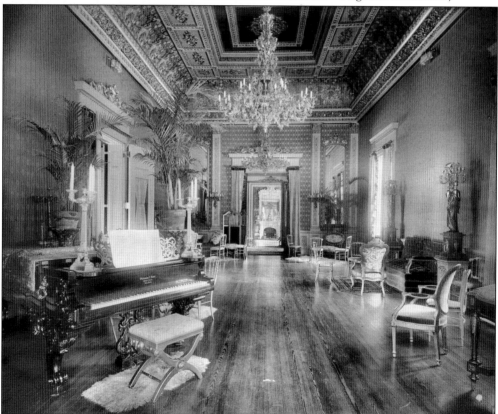

When William Wilson Corcoran bought Daniel Webster's house on H Street at Connecticut Avenue, he hired architect James Renwick Jr. in 1849 to renovate it in the latest style, which introduced the Italianate mode to the city. Added to the formerly 3.5-story Federal house were two large wings and a fourth floor. This 1900 photograph shows Corcoran's ornately furnished large hall and his drawing room beyond.

Behind Corcoran's home was a walled garden, within which he displayed several sculptures of carved and cast decorative urns as ornamental features. Well-known photographer Frances Benjamin Johnston captured these views between 1895 and 1900. Topped by more decorative urns, the gate (right) led out from the garden onto Connecticut Avenue. Another sculptural iron urn is shown below against the home's ivy-covered walls. William Corcoran retired in 1854, six years after he bought the house. His career in the banking industry had made him wealthy. With his affluence, Corcoran became devoted to collecting art and sculpture as well as sponsoring philanthropic endeavors in the region. Different from his colleagues and other art patrons, who were collecting only European art and sculpture, Corcoran became a collector and patron of American artists, and he was one of the first to develop an important American art collection.

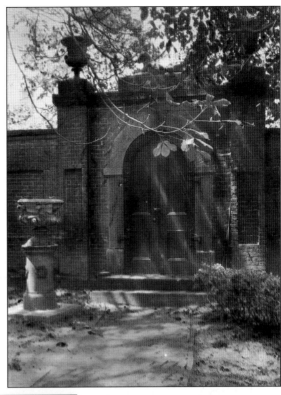

Following William Corcoran's death in 1888, his grandson William Corcoran Eustis inherited the house and rear garden. He did not live in the house, but instead rented it out to a number of government officials and senators, including Calvin Brice of Ohio and Chauncey Depew of New York. These two views of the idyllic character of the garden were captured between 1895 and 1900 by DC-based photographer Frances Benjamin Johnston. They show brick-paved pathways surrounding sections or panels of lawn with ornamental hedges of boxwood bordering a variety of trees and shrubs at the perimeter of the garden. These features are typical of period gardens behind other historic homes that remain in Washington, DC, such as the Octagon Museum, the Woodrow Wilson House, and Tudor Place.

In 1922, the Corcoran house, garden, and stables were demolished to make way for the new US Chamber of Commerce headquarters. Designed by architect Cass Gilbert, the intent of the project was to conform to the Neoclassical style and height standards proposed by the McMillan Plan of 1902, which recommended redevelopment of the buildings facing Lafayette Square and the addition of monumentally scaled cabinet office structures. While the proposal was not enacted at the time, the Commission of Fine Arts regarded it as an ongoing mandate and slowly implemented the plan over the next 50 years. Gilbert was seen as the perfect architect for the job, as he had prepared designs for the US Supreme Court building and the Treasury Annex at the corner of Madison Place and Pennsylvania Avenue, diagonally across the square from the US Chamber of Commerce site.

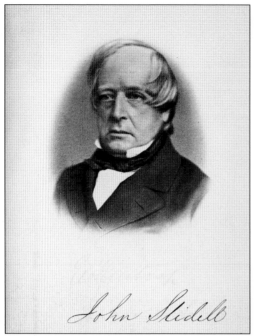

John Slidell

Sen. John Slidell of Louisiana, shown at left in an 1859 portrait, lived at 1607 H Street (below) from 1852 to 1861. Formerly the ambassador to Mexico from 1845 to 1846, Slidell was charged by Pres. James Polk to negotiate an agreement with Mexico, setting the Rio Grande as the southern border of Texas. Slidell suggested that a show of military force at the border might incline Mexico to negotiate; however, the Mexican government rejected Slidell's mission and attacked the forces at Matamoros, which led to the 1846 declaration of war on Mexico. Other famous persons to live in the house included Commodore Richard Stockton in 1840, editor and publisher Thomas Ritchie in 1845, Secretary of the Navy Gideon Wells in the 1860s, inventor Walter Wood in 1891, and Secretary of War Daniel Lamont in the 1890s.

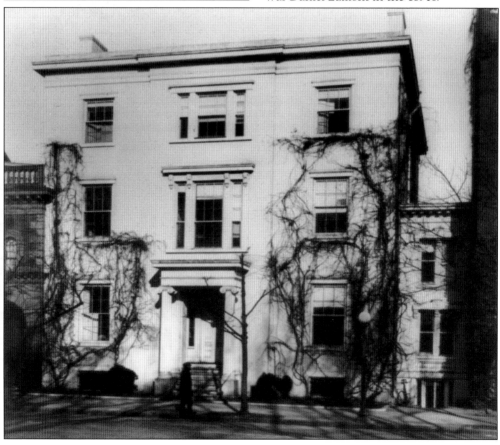

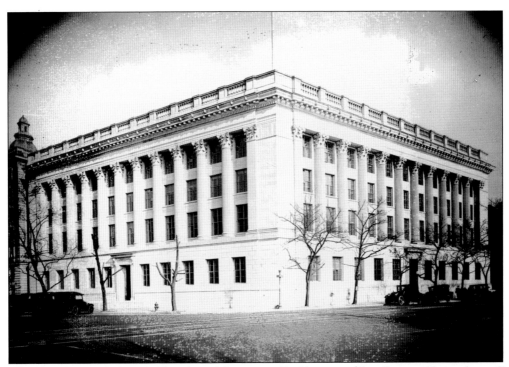

Completed in 1925, the US Chamber of Commerce Building cost $3 million and housed a staff that had grown from four people in 1912 to over 300 in 1922. The building has two main facades, each 11 bays wide. The facade on Connecticut Avenue is seen at left in the above photograph, and the facade on H Street is at right in the above photograph. Typical for Neoclassical works, the building has a symmetrical three-part facade sporting a base, shaft, and top. The one-story base has rusticated limestone over a granite water table. The three-story shaft starts with a simple belt course and includes a colonnade of 10 engaged Corinthian columns framed by pilasters. Crowning the building is a deep entablature supporting a balustrade matching the bays below. Shown below is the plaster model created according to architect Cass Gilbert's design, which was used to gain approval to construct the building.

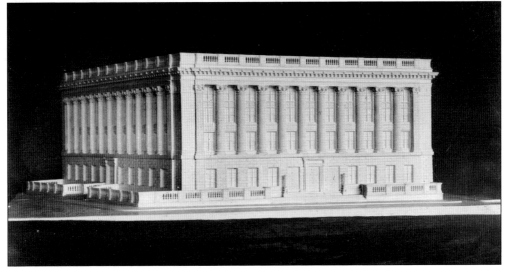

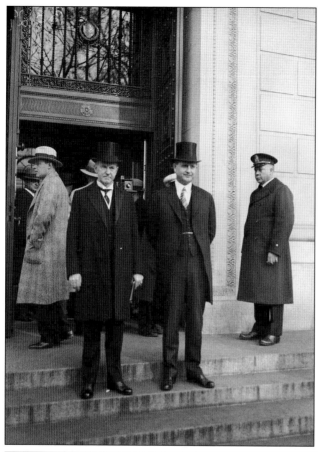

The US Chamber of Commerce Building has a number of first-floor public meeting rooms. The largest and most opulent is the Hall of Flags, designed in the Italian Renaissance style, with teakwood floors, French marble walls, and a deeply coffered ceiling. In the photograph at left, President Coolidge (left) and his secretary, Everett Sanders, leave the US Chamber of Commerce Building, where Coolidge delivered the welcome address at the International Civil Aeronautics Conference in 1928. Every US president from Gerald Ford to Barack Obama has given speeches in the Hall of Flags, as have foreign leaders, such as Egypt's Anwar Sadat and Hosni Mubarak, the Philippines' Corazon Aquino, and India's Rajiv Gandhi. Below, Harry Wheeler, the first president of the chamber of commerce, speaks in the Hall of Flags in 1937 about the progress made by the chamber during its first quarter century.

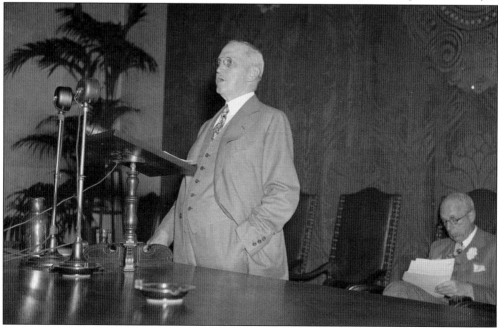

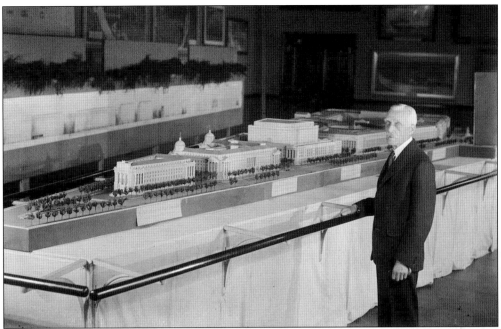

Above, Secretary of Treasury Andrew Mellon poses on April 27, 1929, with a model of the new buildings to be erected as part of the Federal Triangle in Washington, DC. Mellon was the chairman responsible for construction of these new buildings for the government's use. Mellon displayed the building model at the US Chamber of Commerce Building in order to present it to Pres. Herbert Hoover and other government officials. The design of these buildings was one of the last recommendations to be fulfilled from the McMillan Senate Commission's plan for adding new buildings to the city, with the aim of making "the nation's Capital the finest Capital in the world." Shown below during a meeting is the board of director's room in the US Chamber of Commerce Building.

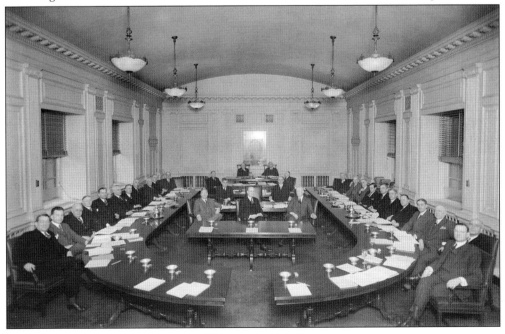

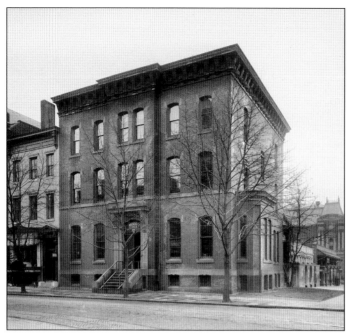

This photograph, taken between 1910 and 1920, shows the southern side of H Street between Decatur House and Seventeenth Street. This is one of the earliest views of this corner. The former residential buildings changed tenants to become the Handicraft School (left) and the American Red Cross building (right). Single-story stables are shown between the Red Cross building and the old Corcoran Gallery of Art in the distance.

John Hay was secretary of state between 1898 and 1905, when China's Boxer Rebellion slaughtered thousands of foreigners and Christians between 1899 and 1901. In this 1901 photograph, crowds surround the Hay-Adams House, awaiting news about the peace agreement between China and the Eight-Nation Alliance of Austria-Hungary, France, Germany, Italy, Japan, Russia, the United Kingdom, and the United States. (Courtesy of The Historical Society of Washington, DC, James M. Goode Collection.)

Shown as the Brazilian embassy between 1921 and 1922, the Henry Adams House (right) was built between 1884 and 1886 as part of a double house (shown below around 1890) that Adams shared with friend and neighbor John Hay. Henry Adams, descendant of Presidents John Adams and John Quincy Adams, was a political journalist, author, and Harvard professor. John Hay, historian and journalist, was President Lincoln's private assistant and biographer. Hay later served as secretary of state. The Hay-Adams House was designed by H.H. Richardson, a well-known architect with an abrasive personality. When Richardson's design for Nicholas and Isabel Anderson was being built in DC in 1883, Richardson lived with them at 712 Jackson Place. They found Richardson to be a "great deal of trouble" as a bully and nag and said he should never stay with a client "because he requires so much attention."

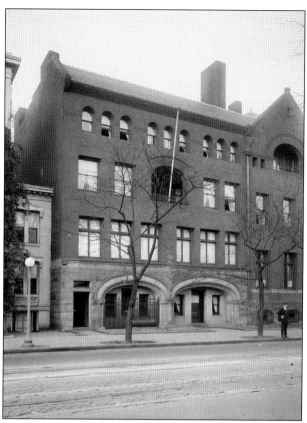

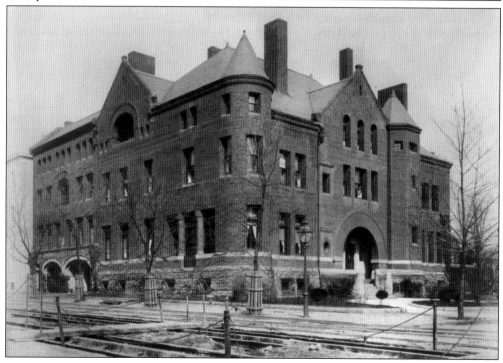

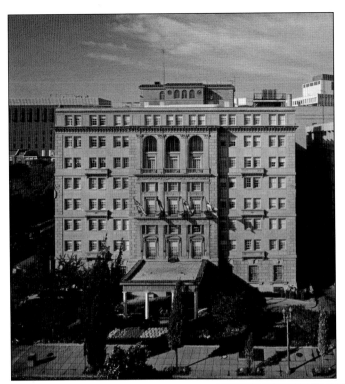

In 1927, Washington, DC, developer Harry Wardman purchased the Hay-Adams property and demolished the homes to make way for a new hotel designed by Wardman's in-house architect, Mihran Mesrobian. The hotel was built in 1928 in the Italian Renaissance style. The hotel is said to be haunted by Henry Adams's wife, Marian, known to friends as "Clover." She killed herself in their home in 1885.

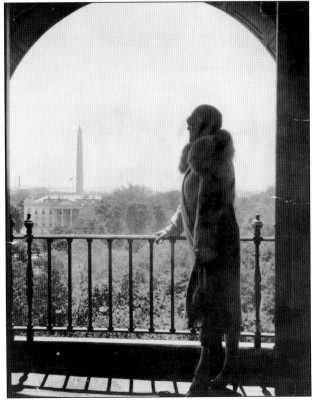

This 1930 view from the Hay Adams hotel looks across Lafayette Park toward the White House. Some parts of the historic Hay-Adams House survived its demolition. The front door and mahogany paneling were saved, as were its facade arches, which were later incorporated into the construction of three other houses. Additionally, the LaFarge stained-glass windows went to the Smithsonian Institution and Villa Stack Museum in Munich.

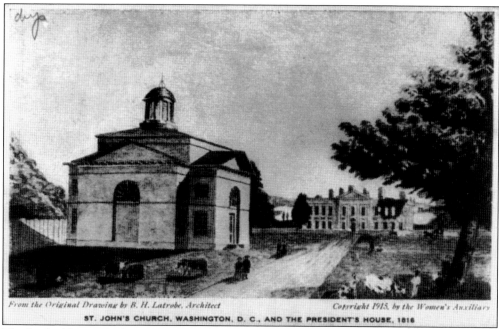

From the Original Drawing by B. H. Latrobe, Architect *Copyright 1915, by the Women's Auxiliary*

ST. JOHN'S CHURCH, WASHINGTON, D. C., AND THE PRESIDENT'S HOUSE, 1816

The first building on Lafayette Square, St. John's Episcopal Church (above), was designed by architect Benjamin Latrobe and constructed between 1815 and 1816 to serve the growing population in the city's northwest quadrant. When built, Latrobe was overseeing the reconstruction of both the White House and US Capitol. Called the Church of Presidents, services have been attended by every president since Madison. A major addition in 1820, designed by George Bomford, lengthened the nave. It is unknown who designed the church steeple, added in 1822. The image below, drawn by Baroness Hyde de Neuville, shows the enlarged church and a fairly realistic view of Lafayette Square's character in 1822. Shown at right is the house built between 1818 and 1819 for Richard Cutts, brother-in-law to Dolley Madison. Cutts was the second controller of the currency when he moved into the house.

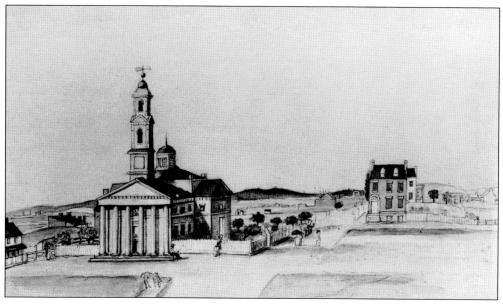

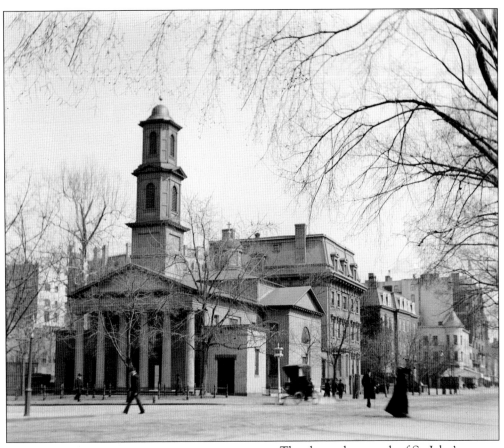

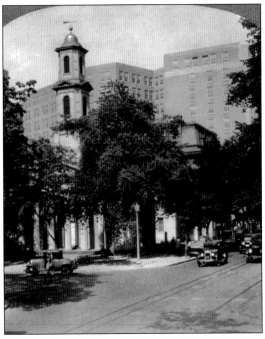

The above photograph of St. John's Episcopal Church, taken shortly after 1890, shows two small additions north and south of the columned portico. Built in the 1880s, these additions accommodated new balcony stairs and were part of the alterations completed by architect James Renwick Jr., who also designed the nearby Corcoran Gallery of Art, now the Smithsonian Institute's Renwick Gallery. The view eastward down H Street shows a residential streetscape that was slowly converted for more commercial uses. The photograph at left, taken around 1928, shows the former Veteran's Bureau Building located behind St. John's Episcopal Church at the corner of H Street and Vermont Avenue. Built between 1917 and 1918, it is the tallest building directly fronting Lafayette Square. It remains in use by the Department of Veterans Affairs. (Left, courtesy of California Museum of Photography.)

Among the earliest photographs of St. John's Episcopal Church is the one at right, showing its chancel at the east end of the church. The 1860 photograph taken before the chancel was enlarged in the 1880s. The rectangular wall, frieze panels, and adjacent moldings located over the three arches are typical details produced in the Classical Revival style by architect Benjamin Latrobe. Unique to this photograph are the flower-shaped crosses on the railing, the floral arrangements at the top of the two side arches, the floral border around the center arch, and the flower-covered apse behind the altar. The expanded view of the church's interior below shows it in 1883, following James Renwick's renovations. Note the Victorian stenciled patterns applied to the surfaces below the dome, and the vegetation covering the wall above the altar.

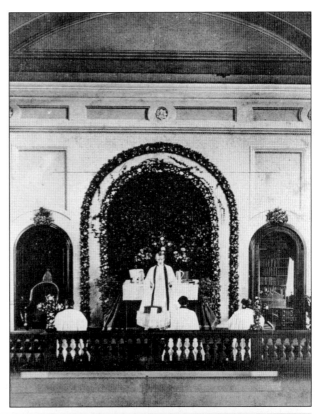

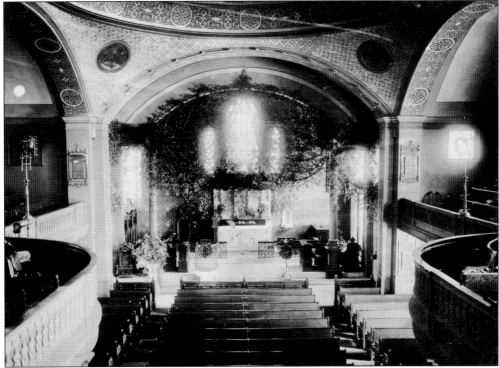

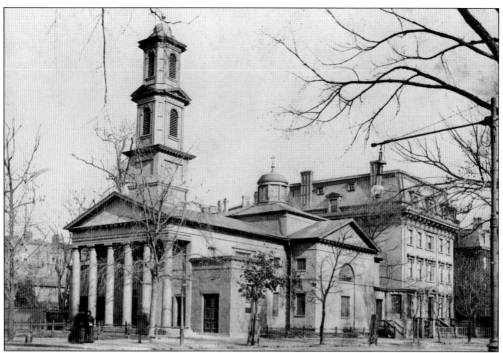

The above photograph, taken in 1890, shows the exterior of St. John's Episcopal Church, which remained unchanged during a major interior renovation by architects McKim, Mead & White in 1919. Much of the work focused on removing the Victorian decoration installed by James Renwick and returning the interior to its Neoclassical style. The work also made modifications to the vestibule and installed marble on the walls of the chancel area around the altar (shown below in 1962). As in many churches, St. John's chancel includes two speakers' stands. The one on the left is called the pulpit, from which the Gospel lesson is often read. The stand on the right is called the lectern, from which laypersons read scripture lessons, lead the congregation in prayer, and make announcements.

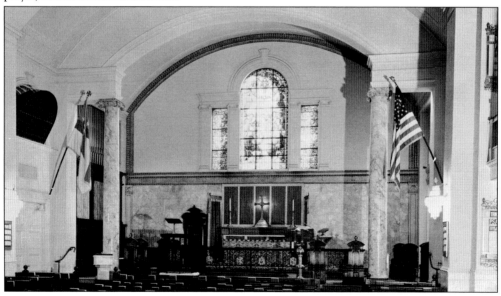

Taken in 1962, these two views show the interior of the nave or sanctuary of St. John's Episcopal Church. At right is the view from the rector's prie-dieu, or prayer kneeler (right), past the pulpit (left) and toward the south balcony. Stained-glass windows were first added to the church as part of the 1880s renovation by architect James Renwick. The photograph below looks west toward the back of the nave, to the doors leading to the narthex and main entrance. Increased illumination levels were part of the 1919 renovation by McKim, Mead & White, which added a new chandelier and other lights, plus the addition and enlargement of perimeter windows. For its architectural design and its history with important architects and presidents, St. John's Episcopal Church was included in the National Register of Historic Places in 1966.

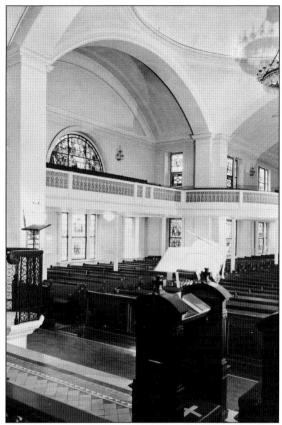

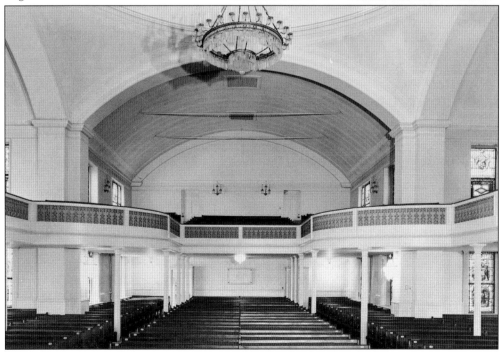

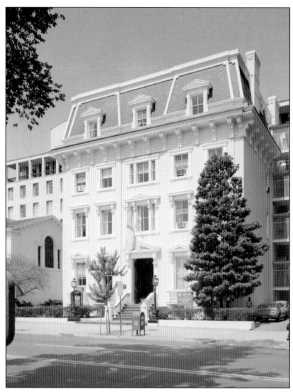

East of St. John's Episcopal Church is Ashburton House (left), named for the first Lord Ashburton of Britain, who occupied the house in 1842. He negotiated the Webster-Ashburton Treaty with Daniel Webster, which settled the US/Canadian boundary. The house was built in 1836 for Matthew Clarke, a congressional clerk, whose financial troubles caused his bankers to take the house. It was then rented to the British delegation for decades. Renovations to the building in 1854 by architect Thomas U. Walter added stucco and elaborate trim at the windows and doors. The mansard roof was added in 1877, resulting in its current appearance. In 1954, St. John's Episcopal Church purchased the house from the AFL-CIO, which had bought it in 1947 to serve as its headquarters. The home's front parlor (below) still contains its original plaster and marble decorative features. (Below, courtesy of St. John's Church Archives.)

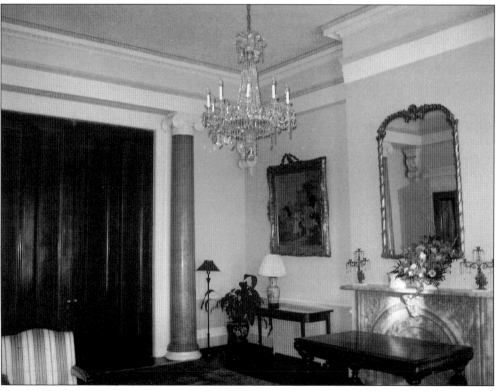

Four

VERMONT AVENUE NW

Vermont Avenue originates at Lafayette Square and extends northeasterly through the city. The avenue connects four major parks—Lafayette Square, McPherson Square, Thomas Circle, and Logan Circle—along its 1.5-mile length. The avenue's development reflects the city's growth from the middle to the late 19th century. Due to its proximity to the White House, construction on Vermont Avenue first occurred around Lafayette Square in the 1860s. Residential expansion then occurred in the 1880s toward Logan Circle, which remains today as the only park along Vermont Avenue that retains its residential scale.

The buildings of Vermont Avenue at the northeast corner of Lafayette Square stand as a cautionary tale of how development around the square could have transpired if commercial and government forces were deferred to. The historical heritage and unique character of the buildings surrounding the square were nearly lost to make way for larger, modern structures.

The first town houses, built in the 1850s and 1860s, shifted toward commercial uses starting in the 1870s, serving as boardinghouses, hotel annexes, shops, and even offices with upper-floor apartments. These structures were then demolished in the 1890s to make way for larger buildings that served as grand hotels and mid-rise office buildings. In 1912, the Arlington Hotel, which occupied the entire block between H and I Streets, was demolished. In its place rose the 11-story Department of Veterans Affairs building. Its designers thumbed their nose in 1918 at the McMillan Commission's six-story building height recommendation for structures surrounding the square and built as high as codes allowed. The VA structure became the square's tallest high-rise. In 1939, its height was surpassed across the street by the 12-story Export-Import Bank of the United States building, designed by the Chicago architectural firm of Holabird & Root. Their design maximized the building size as a speculative venture to lease the structure to the government. Unique features of the building included underground parking and central air-conditioning, which were not yet common in other office space. Today, both structures flank Vermont Avenue with their dense solid massing and represent a building type that could have replaced those surrounding Lafayette Square.

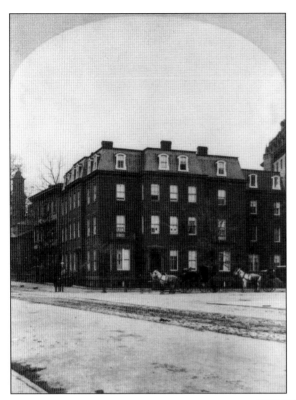

Shown in the 1850s, the corner house on Vermont Avenue and H Street was the home of William Marcy, who was secretary of state while living there from 1853 to 1857. Before his residency, Marcy had a long public career, serving as a New York senator from 1831 to 1833, the 11th governor of New York from 1833 to 1838, and secretary of war from 1845 to 1849. After Marcy's residency, the building became home to Massachusetts senator Charles Sumner from 1865 to 1874.

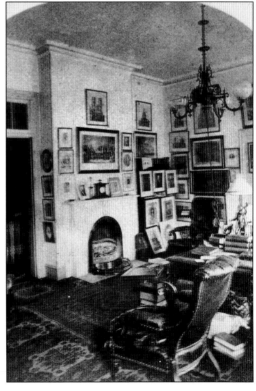

This is the parlor of Charles Sumner's house, filled with his art collection. Before Sumner, other politicians lived in the house. Brig. Gen. Lewis Cass lived there as secretary of war (1831–1836) and as a Michigan senator (1845–1848). During 1861–1865, Kansas senator Samuel Pomeroy reportedly lived at the house while in office. Pomeroy is famous for introducing a Senate bill that led to the creation of Yellowstone National Park. (Courtesy of The Historical Society of Washington, DC.)

This lithograph of Sen. Charles Sumner was published following his death by heart attack on March 11, 1874, at his home across from Lafayette Square. Due to his prominent public service, he laid in state in the US Capitol rotunda, the first senator to do so. Sumner, an outspoken antislavery advocate, was caned and beaten unconscious on the Senate floor in 1856 for his views.

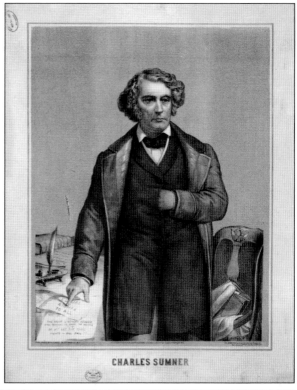

CHARLES SUMNER

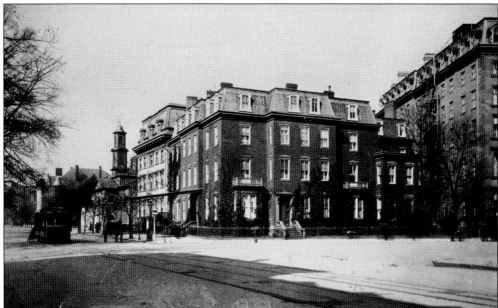

In the late 1870s, Sumner's corner house and the adjacent town houses became the south annex for the Arlington Hotel. To accommodate loading and unloading of guests from horse-drawn carriages, a large porte cochere was constructed over the south entry to the corner building. Supported by thin cast-iron columns, similar porte cocheres were also built at the hotel's two main entrances. (Courtesy of The Historical Society of Washington, DC.)

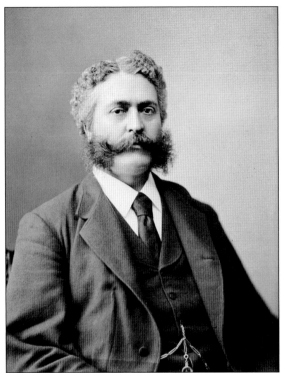

This photograph of Theophile Roessle, taken sometime between 1870 and 1880, shows the popular proprietor of the Arlington Hotel, which was built by William W. Corcoran in 1868. Its location near the White House attracted an exclusive clientele. The attentiveness and care of Roessle's staff made his guests feel comfortable and at home, making it the most well-known hotel in Washington for its time.

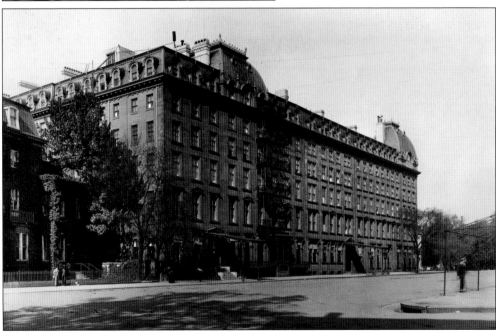

The Arlington Hotel is shown in 1889, after it had received a northern addition designed by Harvey Page. The addition, which complemented the original hotel design by E.G. Lind, added a larger dining room, parlor, more guest rooms, and a new entrance on I Street, leading to an exclusive ladies' promenade. Vermont Avenue was also the first street in the city to be paved with asphalt to quiet traffic noise. (Courtesy of The Historical Society of Washington, DC.)

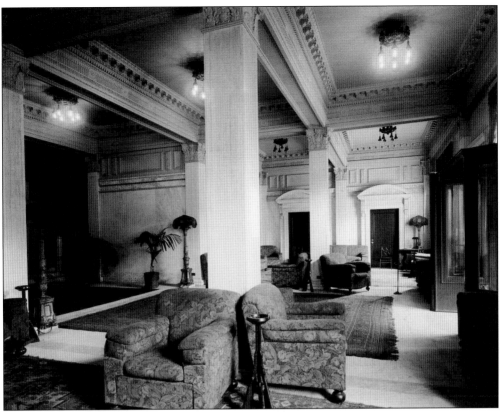

This north view of the Arlington Hotel lobby shows it filled with overstuffed chairs and carpet-clad floors. Notable guests included many politicians and businessmen, including Andrew Carnegie and J.P Morgan, both of whom had permanent suites. State visitors included Dom Pedro II, the second and last emperor of Brazil from 1831 to 1889; Pres. Porfirio Diaz of Mexico; and Queen Kapiolani of Hawaii.

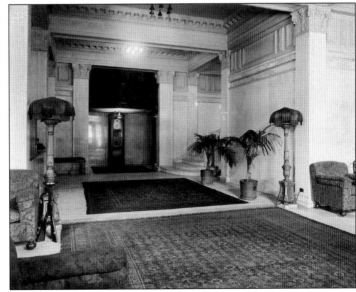

This west view of the Arlington Hotel lobby shows the marble-clad walls around the check-in desk. Opposite the front doors and beyond the desk was a large case clock, also known as a grandfather clock, which patrons used to set their watches. Beyond the potted palms on the right was a flight of stairs that led to the various dining rooms on the upper floor.

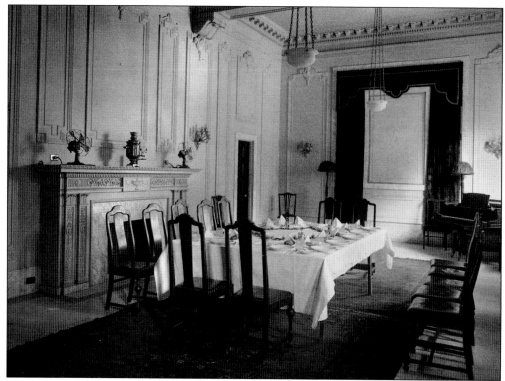

The Arlington Hotel had tastefully decorated private dining rooms that provided a perfect setting for social or business gatherings. The painted plaster walls of the men's private dining room were paneled in the Renaissance Revival style and furnished with sturdy mahogany chairs, richly colored Oriental rugs, patterned velvet drapes beneath matching upholstered window cornices, and a grand piano, should it be needed for dinner music or after-dinner merriment.

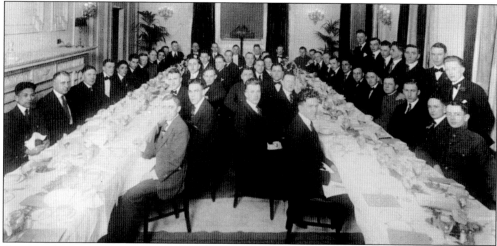

A versatile space, the men's private dining room could accommodate 50 persons. A typical 12-course menu in 1890 included the following: oysters; turtle soup; olives, celery, salted almonds, radishes, and anchovies; filet of sole, cauliflower, and potatoes; chicken cutlets; asparagus; roasted lamb; punch; roasted ducks, currant jelly, and fried hominy; pâté de foie gras and celery salad with truffles; assorted desserts, ice cream, fruit, coffee and cigars; and several wines and liqueurs.

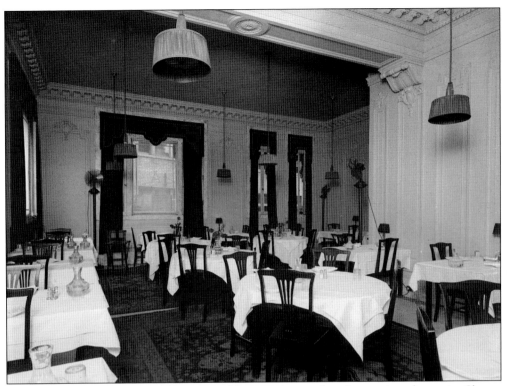

The private dining rooms could be reserved for intimate meals or large private banquets. Shown here, the women's private dining room is set up for typical meal service for its patrons, which included white linen service for all meals. The painted plaster walls were paneled in the Renaissance Revival style. The room was furnished with graceful mahogany chairs, pastel Oriental rugs, and solid velvet drapes beneath matching upholstered window cornices.

Arlington Hotel meals featured a wide variety of desserts, such as the following: baba au rhum, molded rum sponge cake drizzled with rum syrup and topped with whipped cream, fruit sauce or cherries; Neapolitan ice cream, a molded dessert of three layers (chocolate, vanilla, and strawberry); and charlotte russe a la Richelieu, a molded dessert of Bavarian cream mixed with gelatin surrounded by ladyfingers and served with fruit sauce.

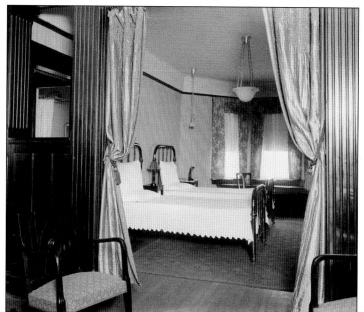

Arlington Hotel guest rooms were furnished to appeal to both male and female patrons. Each room had a wood-paneled sitting room, bedroom, and separate bathroom. Rooms for men had wooden and brass furniture, plain carpets, shades, and heavy curtains. The women's rooms featured upholstered and painted furniture, colorful Oriental carpets, and lace curtains. Satin or velvet drapes separated the sitting room and bedroom, for men or women to receive guests.

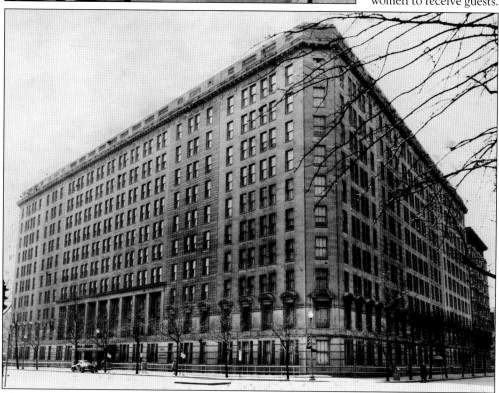

The Arlington Hotel was demolished in 1912 to build a larger hotel; however, funds were lacking. Instead, the owners erected an office building in 1917 to lease space to the government. Before construction was completed, the government bought the building for $4.2 million, opening it in 1918 as offices for the War Risk Bureau. Seen here in the 1940s, the building remains in use by the Department of Veterans Affairs.

The Veterans Affairs building (above, left) and the Lafayette Building (above, second from right) flank this 1990s northeasterly view of Vermont Avenue. The Export-Import Bank of the United States has been the main tenant for the Lafayette Building (below) since it was erected in 1939. The Chicago architectural firm of Holabird & Root designed the 12-story building in the Stripped Classical style. Its goal was to maximize the building size to fill the Vermont Avenue block and lease the building to the government. Unique features included underground parking and central air-conditioning. Original tenants included federal agencies established during the New Deal era, such as the aforementioned Export-Import Bank of the United States, Federal Loan Agency, Federal National Mortgage Authority, and the Reconstruction Finance Corporation (RFC). In 1947, the government bought the Lafayette Building. (Below, courtesy of Carol M. Highsmith Photography, Inc./GSA.)

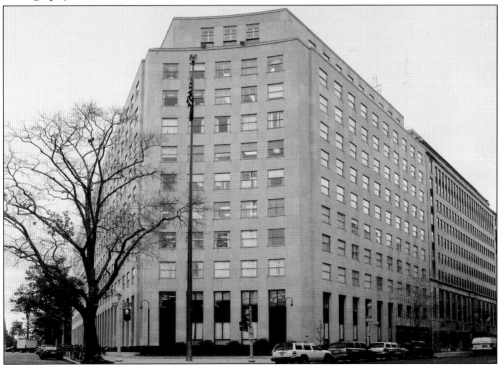

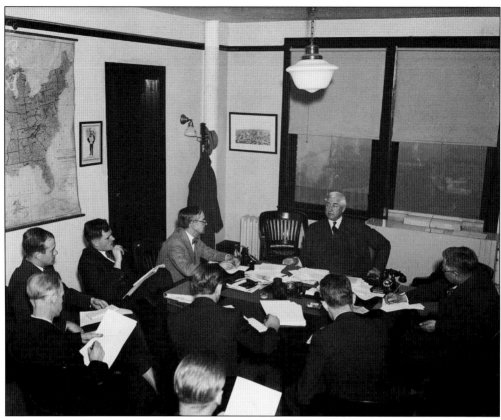

Shown in his office in the Lafayette Building, Jesse H. Jones (right, facing camera) served as the chairman of the RFC, which helped finance mobilization of American industries during World War II. Jones, appointed federal loan administrator in 1939 and secretary of commerce in 1940, kept an office in the Lafayette Building until his retirement in 1945. He was considered the second most important man in American government after Pres. Franklin Roosevelt.

This early-1990s view of Vermont Avenue between H and I Streets shows the Export-Import Bank of the United States (right) and the street's width of 130 feet between buildings. Originating at Lafayette Square, Vermont Avenue connects four major parks along its 1.5-mile length. The existing government office buildings flanking the avenue belie the street's original affluence as a fashionable residential area in the 19th century.

Five

MADISON PLACE NW

Madison Place was initially the location of five residences that were home to, and visited by, many leading American politicians in the 19th century. Initially a gravel carriageway, the street was first named Fifteenth and a Half Street. It was officially named Madison Place in 1859, presumably as a memorial to Dolley Madison, whose last residence was on the street from 1844 to 1849. Coincidentally, her home, built in 1818–1819, was the first house built on the street for her brother-in-law, Richard Cutts, and was visited by many presidents and statesmen while Dolley lived there. Afterward, government officials and military leaders occupied the house.

The second home was built midblock in 1828 for Benjamin Ogle Tayloe, who lived there from 1829 until his death in 1868. An influential and wealthy Whig Party member, he conferred with military leaders, chief justices, congressional leaders, senators, secretaries of state, vice presidents, and presidents. In 1887, Sen. Don Cameron purchased the house. It was later nicknamed "The Little White House" for the many political visitors and meetings held there when it served as home to Vice Pres. Garret Hobart from 1897 to 1899 and Sen. Mark Hanna from 1900 to 1902.

The house south of Tayloe's was built in 1831 for Commodore John Rogers, who occupied it between 1835 and 1838 after first renting it to Attorney General Roger Taney, who later became secretary of the treasury. In the 1840s, it was a boardinghouse used by cabinet-level staff. Anecdotes suggest that Pres. James Polk was a resident for several months in 1845 while White House renovation work occurred. Also, two secretaries of state lived at the house: William Seward from 1861 to 1870 and James Blaine from 1889 to 1893.

At the south end of Madison Place were two more houses. Built in 1868 was the residence of Vice Pres. Schuyler Colfax; the 1831 the corner house was for James Gunnell, a dentist appointed postmaster general. The latter building became a military office during the Civil War.

While modern buildings have filled in much of the street, the Cutts-Madison and Tayloe houses remain at the north end of the street as a testimony to the thoroughfare's early history.

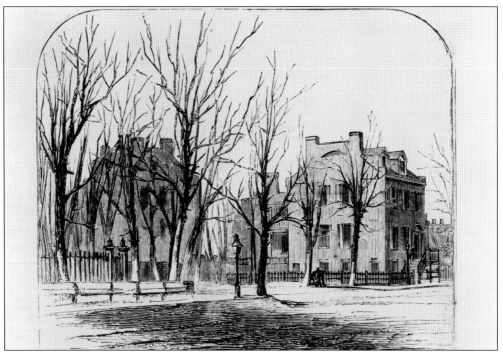

By 1820, a gravel carriageway, named Fifteenth and a Half Street, was on the east side of Lafayette Park. It officially became Madison Place in 1859. Drawn in 1859, these images capture the streetscape around Lafayette Square where Congressman Daniel Sickles shot and killed DC district attorney Phillip Key for having an affair with Sickles's wife. Key was shot at the corner of Madison Place and Pennsylvania Avenue (above), near the high iron fence that surrounded the square. Friends carried the mortally wounded Key to the Washington Clubhouse, the second building on Madison Place from the corner (below left). Key died there in the front parlor. Built in 1831 as the Rodgers House, the structure was converted into a fashionable boardinghouse by A.B. Stoughton in the 1850s, and it became known as the Washington Club.

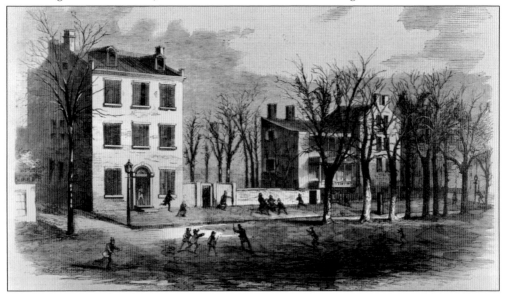

Other misfortunes happened to residents in the former Rodgers House. In 1865, Secretary of State William Seward was attacked and nearly killed by Lewis Payne in the assassination plot against Lincoln administration officials. In the 1870s, Secretary of War William Belknap was impeached, but not convicted, for financial corruption. Between 1889 and 1893, the son and daughter of Secretary of State James Blaine each died, followed by Blaine within a year.

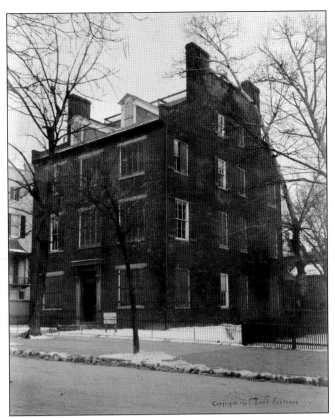

Between 1876 and 1888, the Rodgers House was used as a warehouse for the War Department archives, until the records were relocated to the State, War, and Navy Building upon its completion in 1888. This south-facing photograph, taken after 1919 from H Street, shows the Belasco Theatre, which replaced the Rodgers House in 1895, and the Treasury Annex, built in 1919, at the south end of Madison Place.

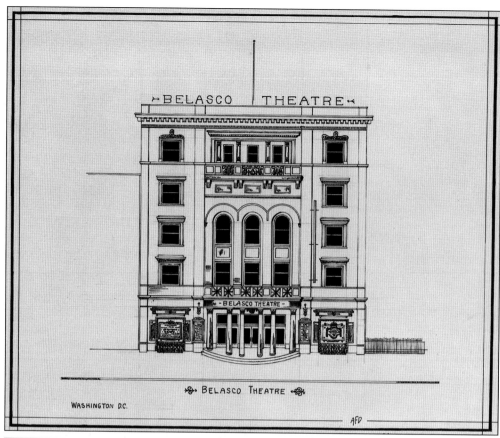

BELASCO THEATRE

BELASCO THEATRE
WASHINGTON D.C.
AFD

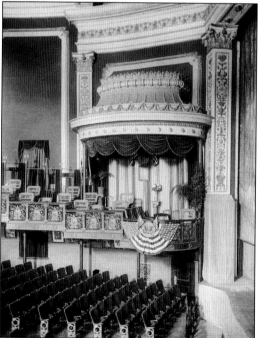

Erected in 1895, the building initially named the Lafayette Square Opera House was dubbed the Belasco Theatre in 1905. Designed by the Chicago firm of Wood & Lovell for owner Uriah Painter, the theater (above) had 1,800 seats. With Ionic columns framing the prominent entry, the six-story building was designed with Italian Romanesque details. Inside, the theater blended Beaux-Arts, Neoclassical, and Italian Renaissance styles and featured three balconies, 30 boxes decorated with ornate gilded plasterwork, and a large, gilded plaster proscenium arch. The theater included a president's box (left) to the left of the stage. Famous performers on the stage included Maude Adams, Ethel Barrymore, Sarah Bernhardt, Enrico Caruso, Katherine Hepburn, Al Jolsen, Will Rogers, and a five-year-old Helen Hayes, who was "discovered" at this theater. It was converted to a movie house in 1935 and demolished in 1964.

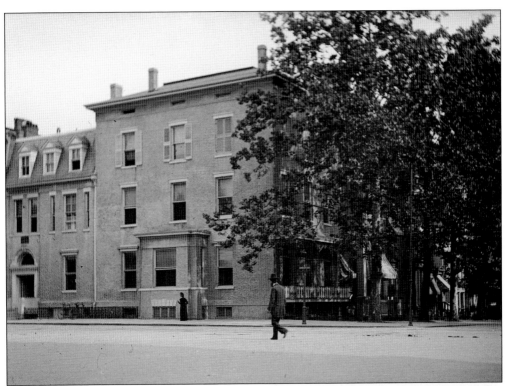

Shown in the 1919 photograph above, the building on the corner of H Street and Madison Place is known as the Cutts-Madison House. Built in 1818–1819 by Dolley Madison's brother-in-law, Richard Cutts, the house was bought by President Madison in 1828 to resolve Cutts's debts so he could avoid jail. After her husband's death, Dolley, shown in the photograph at right in 1848, lived in the house from 1836 to 1839 and again from 1844 to 1849. Upon her death, her son John Payne Todd inherited the house. He sold it to Capt. Charles Wilkes in 1851. Wilkes had been the commander of the first US naval exploration of the Pacific Ocean between 1838 and 1842. Changes made by Wilkes resulted in the house seen today, with its main entry on H Street, a first-floor ornamental, cast-iron balcony, a third floor, and an attic story.

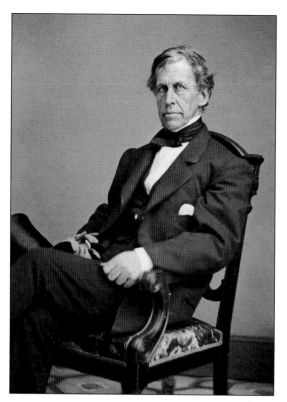

The photograph at left, taken in 1866, shows Rear Adm. Charles Wilkes. He had an accomplished naval career, but he carried a haughty and erratic reputation. He circumnavigated the globe, discovered Antarctica, and commanded the ship involved in the Trent Affair, endangering diplomatic relations with England during the Civil War. But his behavior led to convictions at two court-martials. Wilkes lived in the corner house from 1851 to 1861. In 1861, Gen. George McClellan and his wife, Ellen Mary (below), lived in the Wilkes House and used it for McClellan's headquarters. President Lincoln often visited to meet with McClellan, his chief of staff, or his aides. McClellan moved from the house in 1862 to a larger one farther away on H Street, and the commanding general of the Washington Military District moved in. Wilkes returned to the house in 1864, living there until his death in 1877.

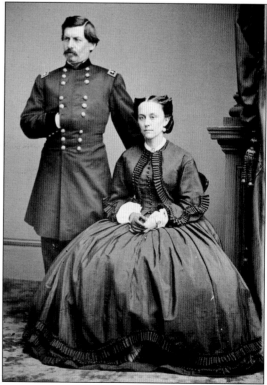

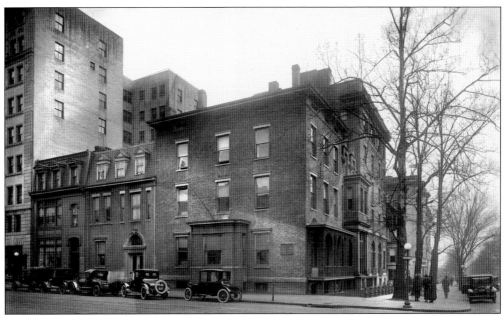

Following Charles Wilkes's death, his wife and three daughters continued to live in the house. They sold it in 1886 to the Cosmos Club, which had been renting a neighboring town house two doors away since 1883. Upon occupancy, architect William Poindexter made some alterations to the house for the club. Later, in 1893, the club hired architects Joseph Hornblower and James Marshall to oversee more renovations and to design an addition next to the house. By 1904, the club purchased and occupied the two town houses south of the addition but demolished them around 1908 to erect a six-story building in 1909–1910 to expand its facilities. In 1917, the club expanded farther into the neighboring Tayloe House, using it as its women's annex, and converted the former stables into a meeting hall. The complex is shown in both 1921 (above) and 1958 (below).

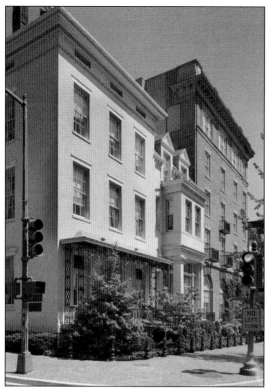

The federal government purchased the Cosmos Club buildings after an offer of $1 million was accepted by the full club membership on March 27, 1940. The club rented the buildings until 1952, when it moved to the renovated Townsend House at 2121 Massachusetts Avenue NW. Following renovation, the government used the buildings to house the National Science Foundation from 1953 to 1958. The National Aeronautics and Space Administration (NASA) was the next tenant, from 1959 until 1964. The first Mercury astronauts to go into space were introduced in the building on April 9, 1959. The corner house (left) was designated a DC historic listing in 1964 and was listed in the National Register of Historic Places in 1970. Between 1968 and 1992, the building was home to the Federal Judicial Center; it then became the US Court of Appeals for the Federal Circuit in 1992 (below).

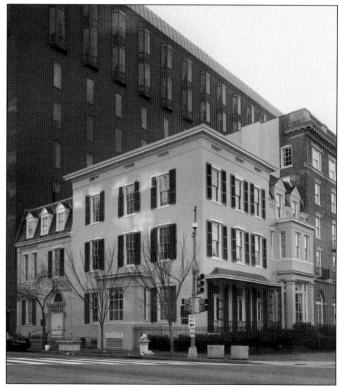

These two photographs and the prior two images represent the Cutts-Madison home both "before" and "after" the exterior restoration completed by the federal government following construction of the federal courts building in 1969 behind the house. Due to procurement requirements, funds were primarily directed toward new construction; renovation and restoration work was to be completed with whatever funds were left over. The original 1818–1819 Cutts residence as renovated by Charles Wilkes in 1851 comprises the three bays on the left (below). The two-bay, dormered addition on the right (below) is the 1893 Cosmos Club addition.

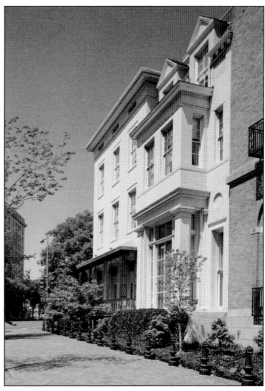

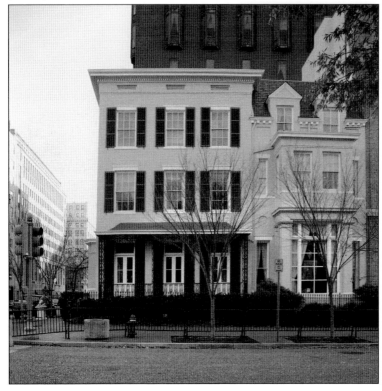

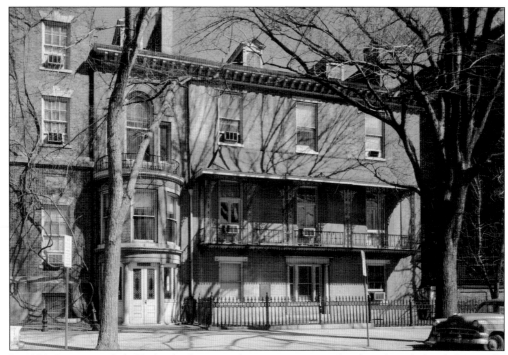

In 1828, Benjamin Ogle Tayloe built a town house comprising the three bays behind the porch, seen at right in the above photograph. Tayloe was one of the most influential and active members of the DC Whig Party, and his home became an important meeting place for American political figures and presidents for 40 years. Sen. Donald Cameron of Pennsylvania bought the house in 1897 and changed the entry from the center bay to a three-story, entry addition on the north, which included a large staircase (below, at left). In 1896, the US Senate passed legislation to make the home the official vice president's residence, but the House of Representatives failed to act on the bill. From 1897 to 1899, Cameron leased the house to Vice Pres. Garret Hobart, causing the home to be nicknamed "the Little White House" for the many political meetings held there.

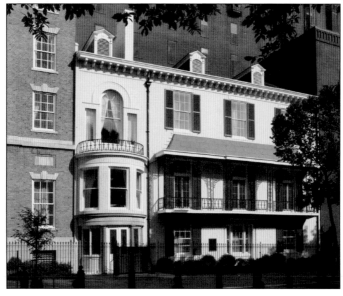

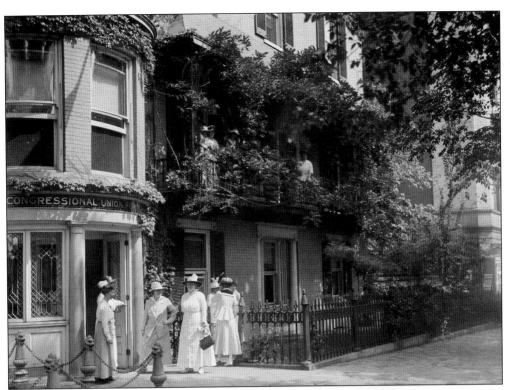

In 1915, Alice Paul rented the Tayloe-Cameron House to serves as the headquarters for the Congressional Union for Woman Suffrage. Paul hoped to amend the US Constitution to allow women the vote, instead of amending state constitutions, which was the strategy of the National American Woman Suffrage Association, the oldest and largest women's suffrage organization. Paul picked the Lafayette Park location in order to stage her campaign opposite the White House and within the president's view.

Well-educated and a Quaker, Alice Paul organized a citywide suffrage parade on March 3, 1913. It overshadowed President Wilson's arrival to DC for his inauguration. As one of the largest protests ever held, it brought greater prominence for suffrage. Paul headed the Congressional Union for Woman Suffrage and the National Woman's Party (NWP). She served six prison terms for the cause, three in England and three in America.

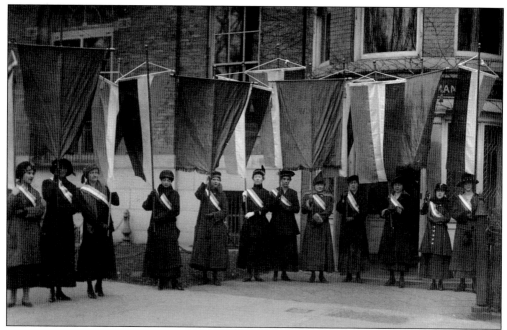

On January 10, 1917, Alice Paul organized the first demonstration to picket the White House. Known as "Silent Sentinels," these women quietly marched around the White House to protest their disenfranchisement and to seek their right to vote. Shown in the above photograph are, from left to right, Berta Crone of San Francisco, Vivian Pierce of San Diego, Mildred Gilbert of San Francisco, Maude Jamieson of Norfolk, Joy Young of New York, Mary Dowell of Philadelphia, Gertrude Crocker of Chicago, Bessie Papandre of San Francisco, Elizabeth Geary of Chicago, Frances Pepper and Elizabeth Smith of DC, and Pauline Floyd of El Dorado, Arkansas. In the photograph below, taken on February 14, 1917, the Sentinels depart the NWP headquarters. In the lead is Hazel Hunkins-Hallinan, carrying the American flag and wearing a sash that reads "Voter."

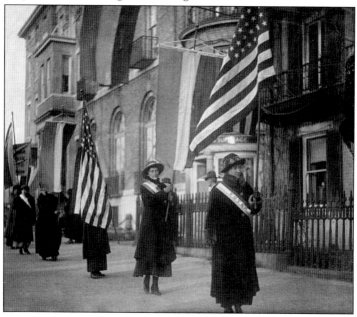

At age 44, Mary Winsor was arrested at the NWP's Draftee Parade on September 4, 1917, and sentenced to 60 days at the Occoquan Workhouse. Upon her release, she again took to the streets with banner in hand to advocate for the NWP. Winsor, from Haverford, Pennsylvania, was educated at Drexel Institute of Philadelphia, Bryn Mawr College, and abroad.

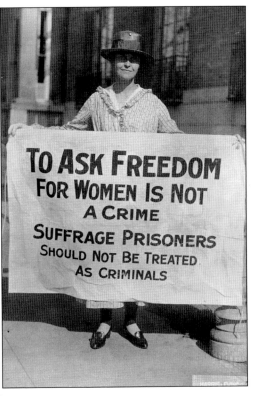

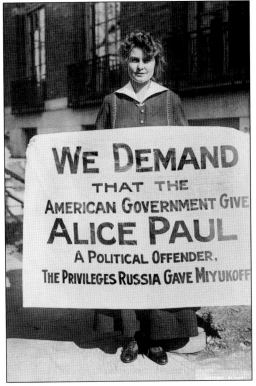

Lucy Branham cofounded the National Woman's Party with Alice Paul. Branham protested on Madison Place against Paul's political imprisonment in November 1917 with the banner shown here. This followed the completion of her own 60-day imprisonment for picketing the White House in September. Extremely well educated, Branham was the daughter of a suffrage activist and a physician from Baltimore, Maryland.

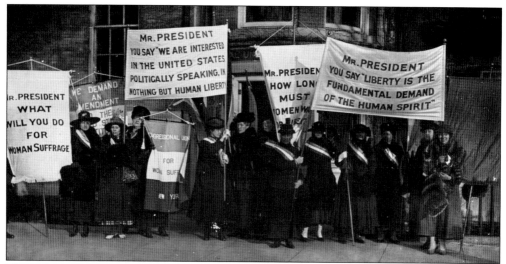

Throughout 1917, suffragettes from various NWP chapters around the nation arrived daily to participate in the Silent Sentinels' continued picket of the White House. Moving beyond banners sporting NWP colors, women made and carried banners using strategic presidential quotes to support their cause and embarrass President Wilson. The banners would eventually incite riots, as bystanders viewed them as anti-American after the United States entered World War I.

This rare photograph, taken behind the Tayloe House, shows the building's back-of-house appearance after the Cosmos Club bought it from Senator Cameron in 1917 and renovated the stables into a meeting hall. Shown here on March 14, 1925, are former Kentucky senator Augustus Stanley (first row, 10th from right) and lawyer Clarence Darrow (left of Stanley) assembled with other DC lawyers. The group is thanking Stanley for his service after he lost reelection.

Six

PENNSYLVANIA AVENUE NW

Pennsylvania Avenue was laid out in the new capital city to link the White House and the US Capitol. Planned as a grand avenue, it is considered the heart of the nation's capital and has been referred to as "America's Main Street" for the many parades, processions, and protests reflecting the various moods of the nation.

The portion of roadway that passes between Fifteenth and Seventeenth Streets NW creates the southern edge of the Lafayette Square neighborhood. For over 200 years, it has been the scene of both jubilation and despair. Citizens have gathered to rejoice or mourn with the various presidents and their families at the White House. Impromptu celebrations have materialized upon word that a battle has been won, peace has been settled, or an international terrorist has been captured. People have demonstrated and exhibited their concerns, hoping to directly influence the country's leader to intercede on their behalf for any number of causes relating to individual rights and world peace.

Pennsylvania Avenue is often the site of major marches, be they military, inaugural, funeral, or protest. Many of these events have involved the construction of elaborate reviewing stands at Lafayette Park to shelter the president, government officials, the public, and, recently, the domestic and foreign media. This chapter provides a number of illustrations to document the variety of parades on the avenue, since few publications have done so. The first organized parade escorted President Madison to his inauguration in 1809; however, it was President Grant who began the tradition of reviewing the inaugural parade at the White House in 1873, shifting the focus to events after the swearing-in ceremony.

In 1995, the portion of Pennsylvania Avenue in front of the White House was closed to vehicles after the Oklahoma City bombing for security reasons, and this change became permanent after the events of September 11, 2001. In 2004, the area was redesigned by landscape architects Michael Van Valkenburgh Associates to improve security measures. At the same time, the design created a sense of openness, avoiding the appearance of a closed stretch of highway. The new design created a gateway to the Lafayette Square neighborhood.

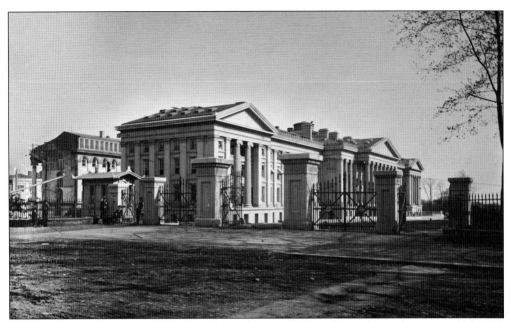

The above photograph, taken in 1867, shows the east (left) and west (center) sections of the US Treasury Building on the south side of Pennsylvania Avenue, a street that was still mostly dirt with stone crossing paths. The street had been fully extended between Fifteenth and Seventeenth Streets, along the southern edge of Lafayette Square, by 1824. Missing from the photograph is the former State Department building, which was demolished in 1866 to construct the US Treasury's north wing, completed in 1869. The fence and gate piers to East Executive Avenue were installed in 1865. Trolley tracks had been installed in 1862 connecting the Capitol with Georgetown. The rare photograph below shows Pennsylvania Avenue looking southwest in May 1865 in preparation for the Grand Review of the Union Armies.

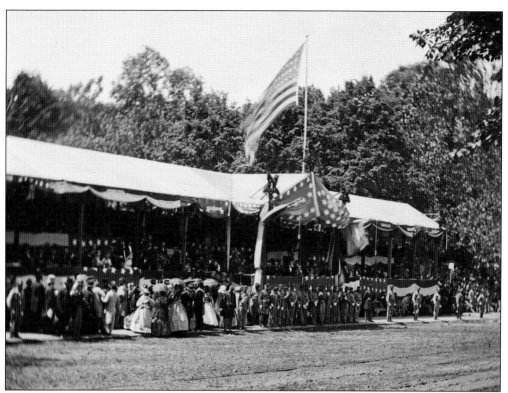

On May 23 and 24, 1865, the Grand Review of the Union Armies participated in one of the largest parades to occur on Pennsylvania Avenue. President Johnson had declared that the rebellion and armed resistance was at an end on May 10. In an effort to change the city's mood, which was still mourning the death of Abraham Lincoln, Johnson decided to hold a formal review of the troops to honor them and to celebrate the cessation of hostilities. Troops with the Armies of the Tennessee, Georgia, and of the Potomac arrived in mid-May and camped in various locations around the city. Shown in both photographs is the reviewing stand in front of the White House, built to seat President Johnson, his cabinet, Generals Ulysses S. Grant and William Tecumseh Sherman, reviewing officers, family, and guests.

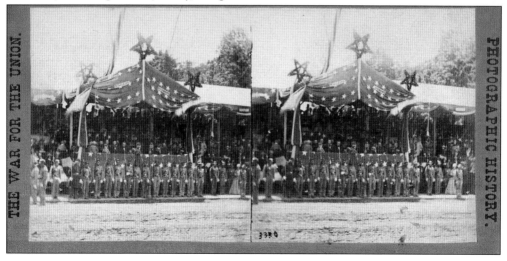

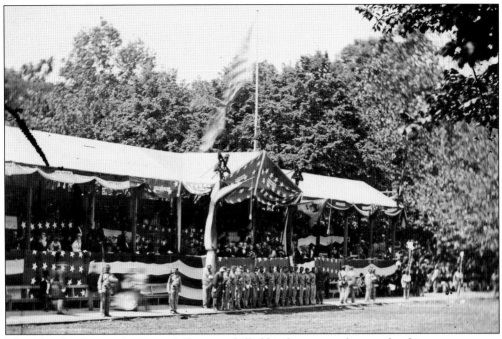

To prepare for the parade, General Sherman drilled his forces to make sure that his western troops would appear as polished as those in the eastern army. Sherman insisted that all "uniforms be cleaned, buttons and brass shined, and that bayonets glistened." The morning of May 23 dawned bright and sunny for the hundreds of thousands who had gathered for the grand review. Leading the parade from Capitol Hill to the White House was Maj. Gen. George Meade, the victor of Gettysburg, followed by the 80,000 men of the Army of the Potomac. When Meade arrived at the reviewing stand, he dismounted and joined the dignitaries to salute his men, who passed by for over six hours.

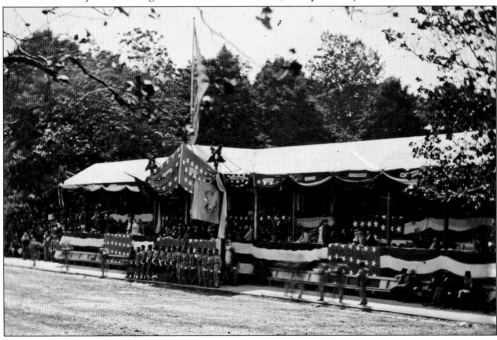

On the morning of May 24, General Sherman led 65,000 men comprising the Army of the Tennessee and the Army of Georgia down Pennsylvania Avenue, past the celebratory crowd lining the parade route. Following Sherman's forces were hundreds of people that had followed the army from Savannah—freed blacks, laborers, travelers, and foragers—as well as a huge herd of cattle and livestock taken from Carolina farms.

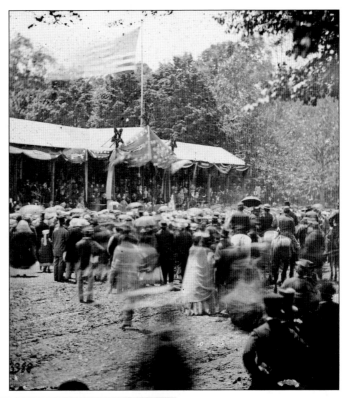

Spectacles like the Grand Review of the Union Armies were not frequent; however, every four years, presidential inauguration parades have become common. The first organized parade escorted President Madison to his inauguration in 1809. President Grant began the tradition of reviewing the parade at the White House in 1873, shifting the focus to postinaugural events. Here, Pres. James Garfield is in his flag-draped reviewing stand on March 4, 1881.

101

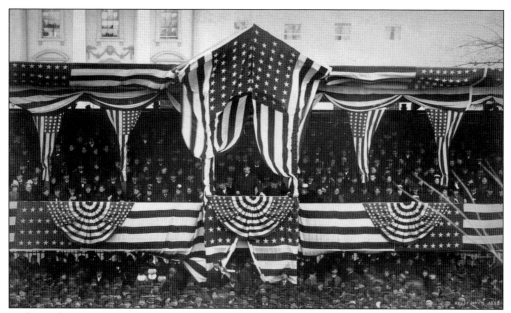

In the 19th century, each presidential inauguration parade seemed to outdo the prior one, with ever more elaborately constructed reviewing stands. In the above photograph, Pres. Grover Cleveland stands at the center of his reviewing stand on March 4, 1885. The stand displays more flag bunting than his predecessor's review. This was the first of Cleveland's two inaugural parades. Despite its temporary nature, Pres. William McKinley's reviewing stand, shown below on March 4, 1897, was more architectural. Ionic columns supported Classical cornices, with bunting draped below them. Dozens of flags flapped in the breeze at the roof. The artist's depiction of viewing stands at left, across the south edge of Lafayette Park, is rare. Stands are typically constructed there for parades, but they are seldom shown. (Below, courtesy of the US Senate Collection.)

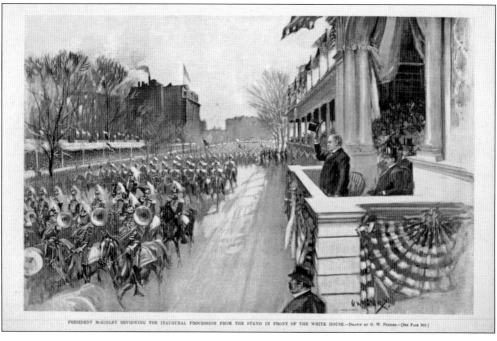

PRESIDENT McKINLEY REVIEWING THE INAUGURAL PROCESSION FROM THE STAND IN FRONT OF THE WHITE HOUSE.—Drawn by G. W. Peters.—[See Page 210.]

In 1859, William Corcoran hired architect James Renwick Jr. to design a museum to house Corcoran's art collection. The building Renwick created is considered the first example of the French Second Empire style to be built in the United States. The style was popular between 1865 and 1880. Typical features of the style include a central wing, gable, or tower feature; corner pavilions; sculptural decoration; and a mansard roof often topped with ironwork, known as cresting. During the Civil War, the government used the half-finished building as a supply depot. Following the war, the building was finished in 1869, and the Corcoran Gallery of Art opened in 1874. From 1879 to 1880, four marble statues from Rome were installed in the second-floor niches. The statues depicted Phidias, Raphael, Michaelangelo, and Albrecht Dürer, representing sculpture, painting, architecture, and engraving.

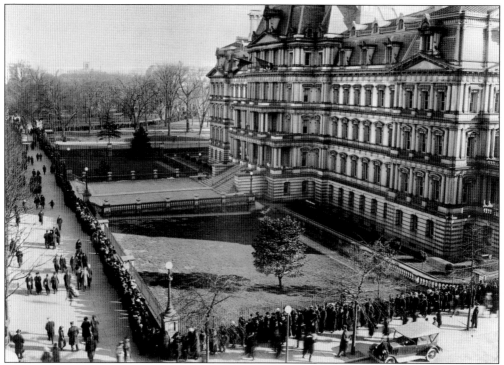

In 1801, Pres. John Adams started the tradition of a New Year's Day public reception, in which anyone could wait in line and shake the president's hand. Shown here in 1922, the line stretches around the block, past the State, War, and Navy Building at Pennsylvania Avenue and Seventeenth Street. Herbert Hoover held the last New Year's Day reception on January 1, 1932. He was out of town in 1933, breaking the tradition.

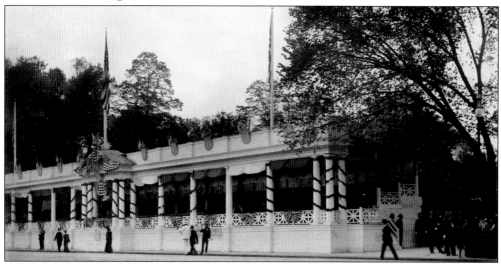

From August 5 to 10, 1902, Civil War veterans held an encampment in DC to celebrate the 36th anniversary of the war's end. A week of activities included a parade in which the commander in chief and Pres. Theodore Roosevelt reviewed the troops of the Grand Army of the Republic, followed by an elaborate reception that night. Shown here is the parade's Neoclassical presidential reviewing stand on Pennsylvania Avenue in front of the White House.

When Republican Theodore Roosevelt was reelected in 1904, he won by the largest popular-vote majority ever received by a presidential candidate. To celebrate, Roosevelt's inaugural parade on March 4, 1905, was among the largest to date, with an estimated 30,000 marchers. Roosevelt led the parade from the Capitol and rose from his carriage often to bow or raise his hat to the onlookers flanking the route. Upon arrival at the White House, Roosevelt, seen at center in the above photograph, joined his family, staff, and dignitaries in the Neoclassical reviewing stand built specifically for the event. Following Roosevelt in the parade were the famous Rough Riders, who were then trailed by the various military divisions (below). Opposite the president's reviewing stand in Lafayette Park was a copy of the large Neoclassical reviewing stand but without the president's box.

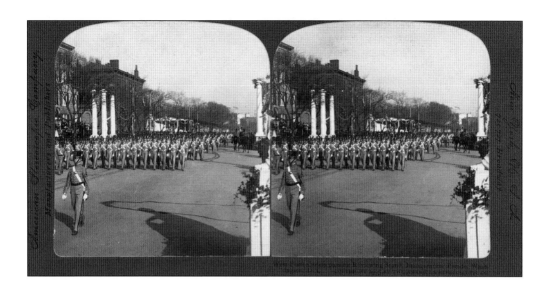

Framing the parade route east and west of the White House were pairs of three columns each, visible at left in the above photographs. Also marching in the parade were West Point cadets (above) and the US Naval Academy midshipmen (below). An Associated Press story on the parade reported that the cadets "marched like veterans and although many of them had friends, relatives, and sweethearts" along the parade route, "they never turned their eyes to the right or left, but marched like clockwork. The midshipmen surprised everybody. Sailors are not supposed to be good foot soldiers, yet beyond question, the two battalions from Annapolis, 700 strong, gave the West Pointers the hardest contest they had ever had for first place in a parade. The boys . . . marched with a precision that was wonderful and were cheered at almost every step." (Below, author's collection)

INAUGURAL PARADE MARCHING TO WHITE HOUSE REVIEWING STAND, MARCH 4TH WASHINGTON, D.C.

Anticipating entry into World War I and to renew Americans to the nation's democratic ideals, Pres. Woodrow Wilson issued a call to hold Preparedness Day parades in June 1916. In DC on June 14, Flag Day, 60,000 participants paraded from the Capitol's Peace Monument to the Washington Monument, passing north of the White House. Leading the parade were DC's chief of police, a police platoon, the grand marshal, the Marine Band, and President Wilson. Following were the White House staff, members of the courts, and Congress. Then followed groups of military organizations, schools, churches, charities, patriotic and fraternal bodies, commercial and industrial contingents, professional men, clubs, and citizens' associations. More than 50 bands were included (one is seen above). The last to follow were 11 segregated divisions. Upon reaching the White House, President Wilson presided over the parade in a reviewing stand on Pennsylvania Avenue (below).

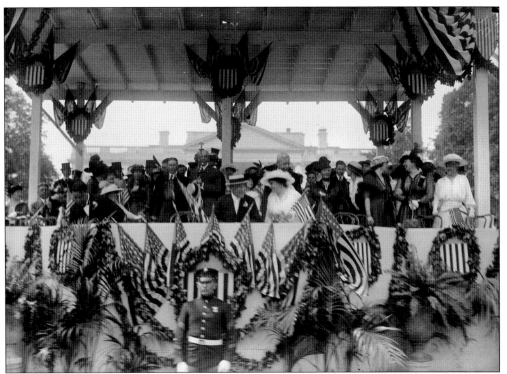

Upon arriving at the White House during the Preparedness Parade on June 14, 1916, President Wilson (center) joined his wife, Edith (center right), in the reviewing stand on the north lawn of the White House. Other dignitaries and spouses joined the president and Mrs. Wilson in the stand, including members of the Parade Committee, who had walked alongside the president to lead the parade.

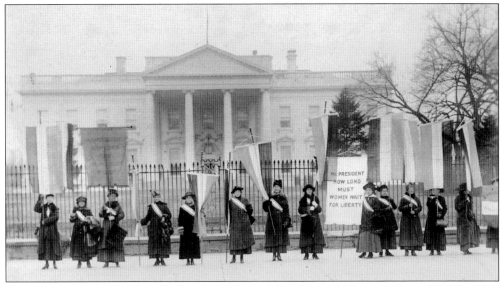

Shown in January 1917, Alice Paul and members of the National Woman's Party (NWP) picket the White House by marching around the building as Silent Sentinels. To help raise national awareness for the suffrage movement, the women marched every day, in all forms of weather, willing to endure sore feet and harsh conditions to gain the right to vote.

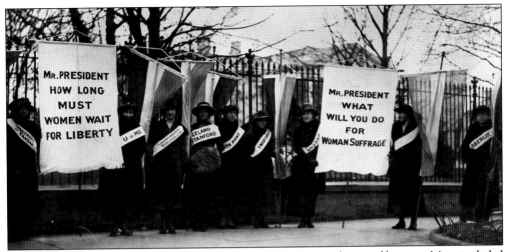

Each day during their picket of the White House, the Silent Sentinels carried banners. Many included the NWP colors of purple, white, and gold. Other banners (above) exhorted the president to allow women the right to participate in the nation's democracy, such as: "Mr. President How Long Must Women Wait For Liberty" and "Mr. President What Will You Do For Woman Suffrage." The above photograph shows the first picket line to include college students, from schools such as University of Kansas, University of Missouri, Washington College of Law, Stanford University, Bryn Mawr College, Swarthmore College, Vassar, and Oberlin College. The photograph below shows three NWP members from New York picketing in the rain on January 26, 1917.

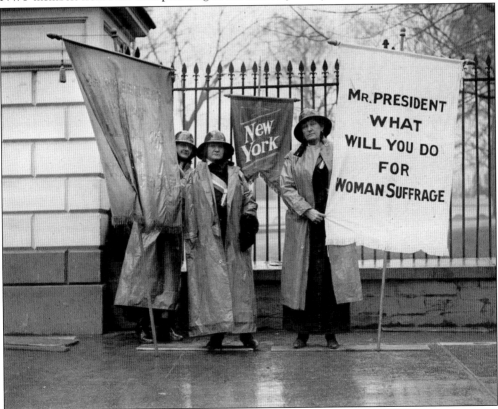

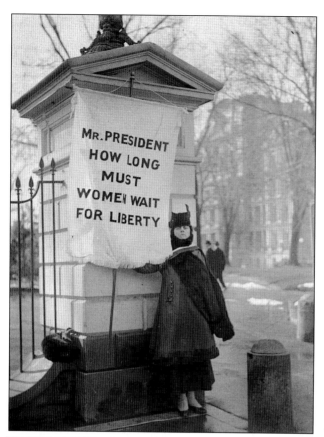

During its picketing of the White House, the NWP published weekly stories and photographs in its newspaper, *The Suffragist*, which was sent to members across the United States. On January 30, 1917, a photograph captioned "Fourth Week of the White House Guard" showed New Jersey member Alison Turnbull Hopkins (left) stationed at the entrance driveway, making herself highly visible to all who entered the grounds. As the Silent Sentinels kept up their vigil through the winter, spring, and summer, larger crowds began to attend. The police initially left the women alone, until the crowds began to block traffic. Beginning on June 22, 1917, the women were routinely arrested on the technical charge of obstructing traffic.

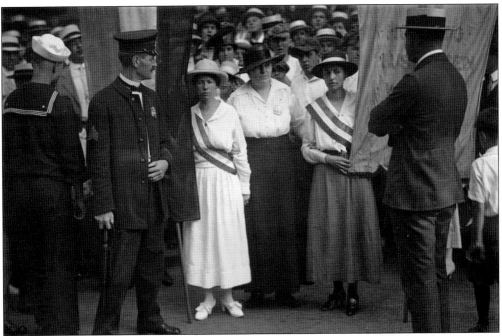

By August 1917, the crowds got out of hand. Some viewed the picketers as unpatriotic and wanted to halt the demonstrations. Others saw an opportunity to bully the women, aware that their actions would not be penalized. In some instances, insults and rocks were thrown at the women. In other instances, men tore the NWP banners to shreds, grabbed at the women's sashes to rip them off, knocked the women down, and choked them. These photographs show Catherine Flanagan of Hartford, Connecticut (left), and Madeleine Watson of Chicago, Illinois (right), wearing their distinctive sashes, next to the arresting policewoman (center). They were arrested for picketing the White House East Gate and thereby obstructing traffic. During the arrest, policemen encouraged the crowd to heckle the women.

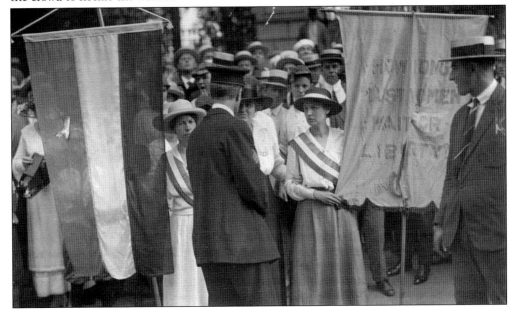

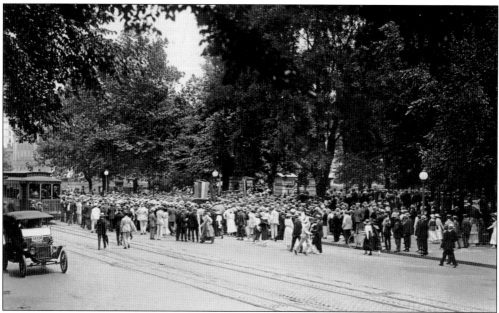

On August 14, 1917, angry mobs taunted and attacked the women picketing the White House. Several women were injured, the NWP headquarters on Madison Place was vandalized, and over $1,000 in damages was caused. For five days, the police made no effort to stop the riots, but instead waded into the fray to arrest the women. Charged with obstructing traffic, the women received lengthy sentences at the Occoquan Workhouse.

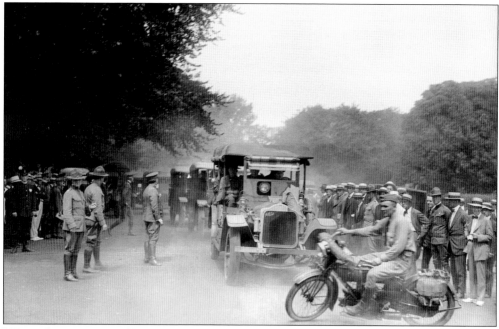

US involvement in World War I began on April 6, 1917, and lasted until November 11, 1918. By the end of the war, the US Army had developed a new motorized combat force, including trucks and tanks. As a publicity stunt, a number of soldiers embarked on a trip around the world by truck, leaving from Lafayette Square in 1919. It is unknown if they succeeded.

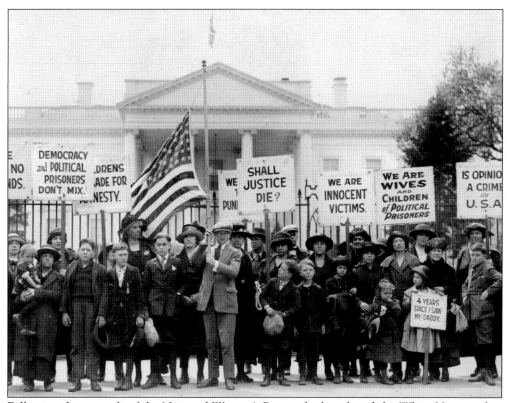

Following the example of the National Woman's Party, which picketed the White House, other groups began to do the same following World War I. Shown here on April 29, 1922, is a group of women and children who came to Washington to appeal to Pres. Warren G. Harding to release political prisoners.

Shown in the 1925 inaugural parade reviewing stand are Pres. Calvin Coolidge (center left) and Vice Pres. Charles Dawes (right), flanked by their spouses. This is one of the smallest presidential reviewing stands ever built. A roof was not installed over the entire reviewing stand, as had been done for past parades. Instead, the roof only covered the booth sheltering the president, vice president, and their spouses.

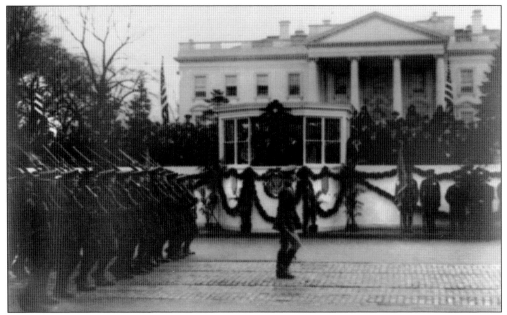

Photographed on March 4, 1925, President Coolidge reviews the troops during his second inaugural parade. This marked the beginning of his second term as the 30th president of the United States. His inaugural ceremony at the US Capitol was the first to be broadcast nationally by radio, and it was the first time that a former president (William Taft) administered the oath of office as chief justice of the Supreme Court.

Looking southwest on Pennsylvania Avenue one week before the inauguration of Pres. Herbert Hoover in 1929, the presidential reviewing stand is not completed or painted, and it is covered by a recent snowfall. This reviewing stand is similar to nearly all of those that followed, sheltering only the presidential reviewing stands and leaving the flanking bleachers uncovered.

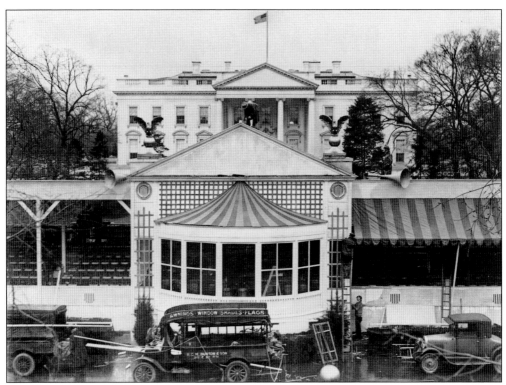

Shown a few days prior to the March 4, 1929, inauguration, the presidential reviewing stand (above) remains under construction while awnings are built to cover seated areas in front. Inaugural stands often used canvas as a temporary roof over the bleachers, but this stand was the first to utilize decorative fabric awnings. President Hoover's inauguration was also the first time an inauguration was recorded by sound newsreels. The photograph below shows the completed presidential reviewing stand with its awnings, lattice, floral garlands, flags, and decorative hedges finally in place. Very few chose to be seated in front under the awnings, as a heavy rain began just before the oath of office was administered and continued during most of the parade. In this photograph, President Hoover and his guests review the passing military artillery.

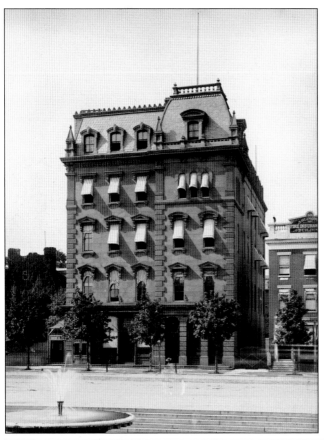

Built in 1831, the first house on the corner of Madison Place and Pennsylvania Avenue belonged to James Gunnell, President Van Buren's postmaster general. Later occupants included military officers and government employees. In 1873, the Freedman's Savings Bank was built on the eastern part of the property at a cost of $260,000. The bank is shown at left in 1890; it is seen below in 1899. Founded in 1865, the bank was formed to help newly emancipated African American communities following the Civil War. Initially successful, the bank developed financial troubles from poor speculative investments. The financial panic of 1873 caused the bank to close in 1874. Some depositors recouped up to 62 percent of their savings through a government program, but many customers lost all their savings, fueling their distrust of banks and the government.

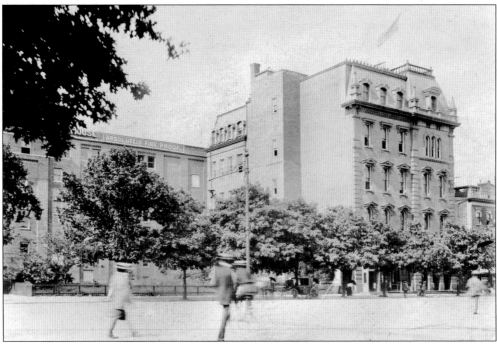

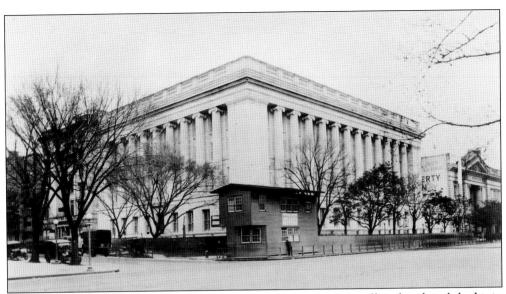

The government acquired the Freedman's Savings Bank in 1882 for offices but demolished it in 1899. The site was vacant until 1917, when construction started on the US Treasury Annex, shown above in 1919. To complement the Treasury Department building across Pennsylvania Avenue, architect Cass Gilbert designed a Neoclassical structure inspired by the McMillan Commission recommendations in 1902 for new office buildings around Lafayette Square. Gilbert's design was intended to occupy the entire east side of Madison Place, but only the southern third was built, seen below around 1930. Built in 14 months during World War I, construction was allowed because office space was critically needed for US Treasury staff to collect and process tax revenues to help fund war expenses. To speed up construction, President Wilson signed an executive order waiving the eight-hour workday rule for annex work crews.

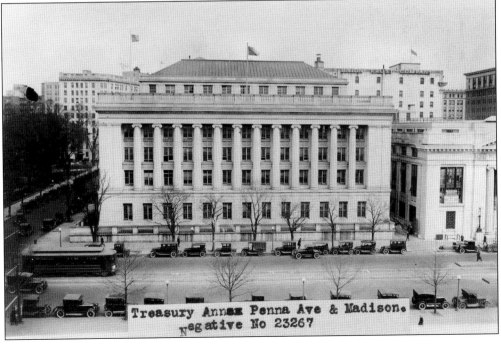

Treasury Annex Penna Ave & Madison.
Negative No 23267

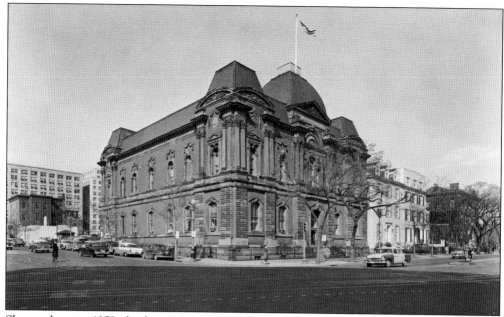

Shown above in 1958, the former Corcoran Gallery of Art was used by the US Court of Claims from 1899 to 1964. These photographs were taken to document the building's architectural qualities, as the government had proposed demolition of the structure in 1956 in order to erect a new government office building. The government had already demolished buildings behind the former gallery (above, left). Even the neighboring structures, the Blair House (built in 1824) and the Lee House (built 1859), were slated for demolition. These two buildings are seen at right in the above photograph. After the art museum left the premises in 1899, nearly all of the second-floor sculpture niches became windows (below). Originally, the niches held statues of Canova, Crawford, Da Vinci, Murillo, Rembrandt, Rubens, and Titian. Only the bronze medallion of William Corcoran, installed in 1886, remains in place on the front of the building.

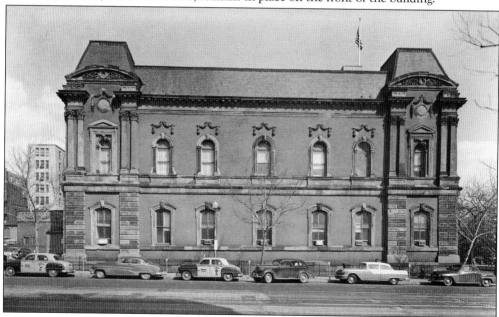

Shown here in 1958 is the interior monumental staircase that leads from the front entrance on Pennsylvania Avenue to the upstairs Grand Salon, which had been renovated to be offices for the US Court of Claims. In 1965, the building was given to the Smithsonian Institution, to be used "as a gallery of art, crafts, and design."

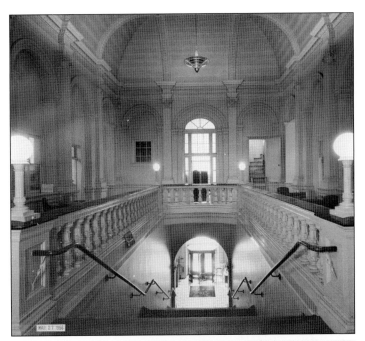

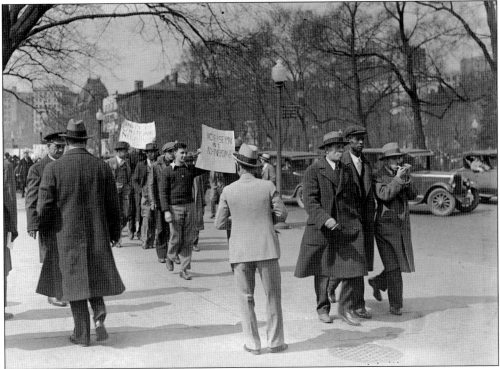

The DC Communist Party organized a multiracial demonstration to picket the White House on March 6, 1930, as part of a nationwide unemployment protest. Thousands came to watch, causing a riot in which 11 men and women were arrested. A dozen persons were injured when police used force and teargas to quiet the event. Solomon Harper (second from right), a leader within the African American Communist Party, helped to organize the event.

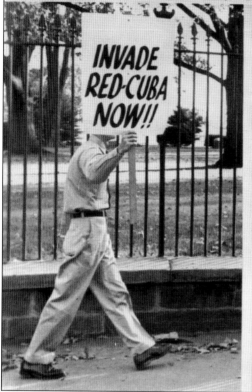

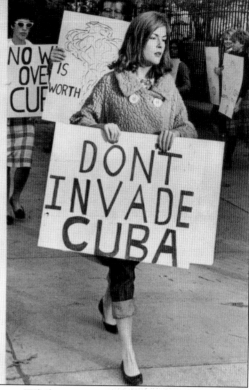

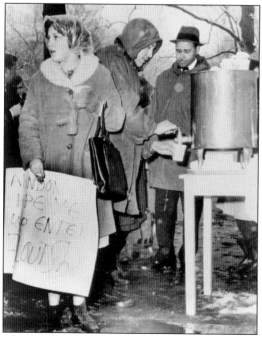

While tense negotiations played out in the White House during the Cuban Missile Crisis, several groups with divergent views picketed outside. Demonstrators included members from the Student Peace Union, a pacifist organization; a group of Cuban students and refugees aligned with the Young Americans for Freedom, a right-wing group in favor of invasion; a group of the khaki-clad, American Nazi Party with swastika armbands (above, left), who favored invasion; and Women Strike for Peace, who were against an invasion (above, right). The *New York Times* reported that "1,000 to 1,500 persons were in the various picket lines" at the peak of the protests. Later in 1962, other demonstrations protested the ongoing arms race (left). These events were cordial enough that White House staff set up coffee stands for the protesters.

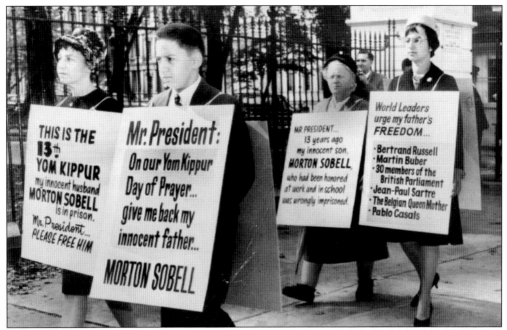

Pennsylvania Avenue saw many protests in the 1960s. The family of Morton Sobell picketed in October 1962 (above), seeking his release. Sobell was arrested for links to Ethel and Julius Rosenberg, who had passed military secrets to the Soviets. Shown above are, from left to right, wife Helen; son Mart; mother Rose; and daughter Sydney. In the photograph below, taken on January 19, 1968, students demonstrate against the war in Vietnam. One sign, "Eartha Kitt speaks for the women of America," relates to actress and singer Eartha Kitt's frank response to Lady Bird Johnson at a White House luncheon when asked about the war. Kitt said, "You send the best of this country off to be shot and maimed. No wonder the kids rebel and take pot." Her response caused Johnson to cry, and it derailed Kitt's career.

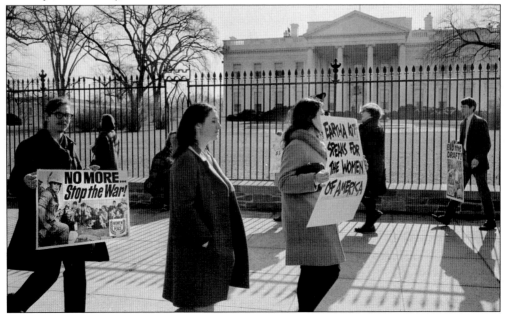

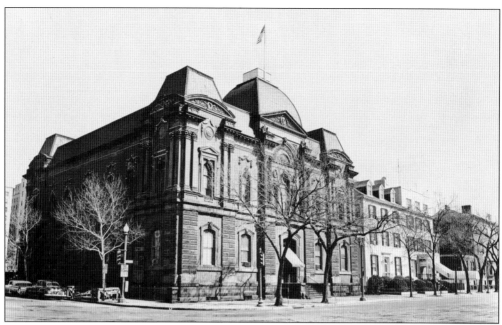

In 1965, the exterior restoration of the former Corcoran Gallery of Art (above) was completed by the architectural firm of John Carl Warnecke and Associates from San Francisco, in conjunction with Universal Restorations, Inc., of Washington, DC. Architect Hugh Newell Jacobson, based in DC, oversaw the interior renovation and restored the Grand Salon (below) to its former glory. The building was added to the National Register of Historic Places in 1969, and it was designated a National Historic Landmark building in the Lafayette Square Historic District on November 11, 1971. The building was renamed the Renwick Gallery in honor of James Renwick Jr., its original architect, and it opened on January 28, 1972, as the home of the Smithsonian American Art Museum's contemporary craft and decorative art program.

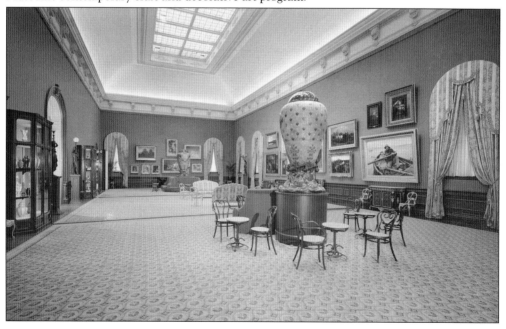

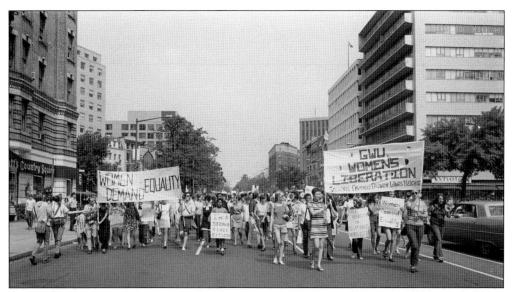

On August 26, 1970, a nationwide demonstration for women's rights coincided with the 50th anniversary of women's suffrage. In DC, the demonstration (above) marched from Farragut Square through Lafayette Square to the White House. The Women's Strike for Equality was organized by the National Organization for Women and its president, Betty Friedan. The strike asked women to stop work for a day to protest unequal pay. *Time* magazine called the event "the first big demonstration of the Women's Liberation movement." Opposing the Equal Rights Amendment during the 1970s was lawyer and activist Phyllis Schlafly (below). She was the organizer of the STOP ERA campaign ("STOP" stood for "Stop Taking Our Privileges"). Schlafly argued that the ERA would strip women of privileges they currently enjoyed, such as dependent-wife benefits under Social Security and exemption from Selective Service registration.

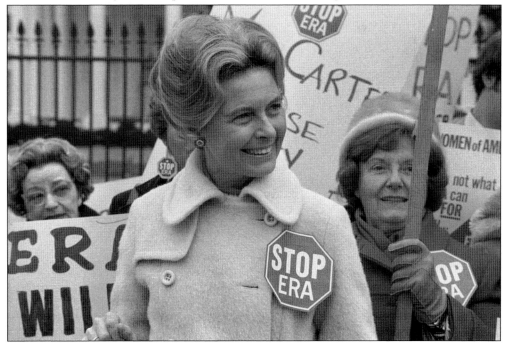

The inaugural parade for Pres. Jimmy Carter on January 20, 1977, had several firsts. The presidential reviewing stand was the first to have solar heating panels and to offer handicapped-accessible viewing. The stand was also the first to be angled to simultaneously maintain a view to the White House and provide a direct view east to see the oncoming parade.

The Lafayette Square Historic District is both opposite of and next to the White House. Built in 1792, the Executive Mansion was reconstructed between 1815 and 1817 after it was torched by the British. Key features seen from Lafayette Square include the round pool and fountain, added in 1871; the boxwood hedge, planted in the 1930s; and the portico, which was added between 1829 and 1830.

In 1978, the paint on the exterior walls of the White House began to fail. An assessment found that some areas, such as the North Portico (above), had as many as 40 layers of paint. The failing paint was removed, and work was begun to repair the original sandstone to provide a strong substrate for the new paint. When the stone exterior restoration project entered its last phase in 1988, the White House, the National Park Service, and the Historic American Buildings Survey decided to complete a five-year project to draw and document the exterior elevations, to provide accurate documentation to help in future repair and restoration work. These photographs date to 1985, when the North Portico and the decorative stone details of the north front entrance (right) were stripped of their paint layers to repair and restore the stone.

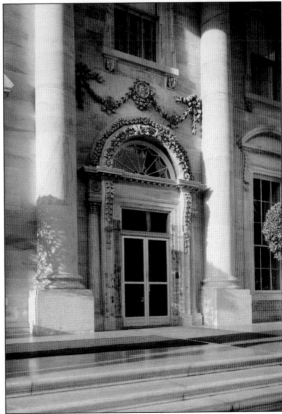

The inaugural parade reviewing stand for Pres. George H.W. Bush is shown in this photograph from January 20, 1989. While each stand is custom built for its temporary location, the 1989 iteration established a new template for all the stands that have followed. The day also served as the 200th anniversary of the presidency, and George Bush took the executive oath using the same Bible used by George Washington in 1789.

At the end of the inaugural parade, Pres. Barack Obama and First Lady Michelle Obama (center) exited the presidential limousine at Fifteenth Street NW and walked the remaining portion of the route on Pennsylvania Avenue NW to reach the presidential reviewing stand. The inauguration ceremony on January 20, 2009, was viewed by a crowd totaling between 1.2 and 1.8 million people, the largest number to ever attend an inauguration.

In this photograph, taken on January 24, 2009, Native Americans in the inaugural parade greet Pres. Barack Obama (center left) and Vice Pres. Joseph Biden (center right) in the reviewing stand. The 56th inauguration saw the largest attendance of any presidential inauguration in US history and the largest attendance for an event in the history of Washington, DC.

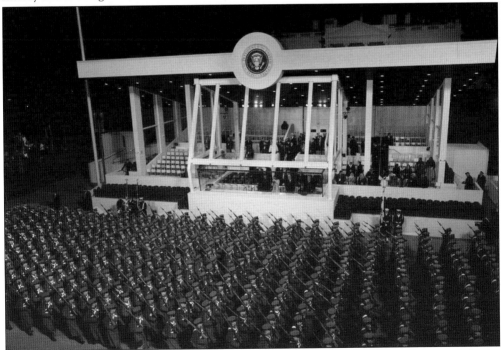

Barack Obama is both the first African American and the first citizen born in Hawaii to hold the office of president of the United States. As the 2009 inaugural parade wound down, President Obama and First Lady Michelle Obama (center left) and Vice President Biden (center right) remained in the reviewing stand until the last marching division passed. (Courtesy of Karen Ballard.)

Discover Thousands of Local History Books
Featuring Millions of Vintage Images

Arcadia Publishing, the leading local history publisher in the United States, is committed to making history accessible and meaningful through publishing books that celebrate and preserve the heritage of America's people and places.

Find more books like this at
www.arcadiapublishing.com

Search for your hometown history, your old stomping grounds, and even your favorite sports team.

Consistent with our mission to preserve history on a local level, this book was printed in South Carolina on American-made paper and manufactured entirely in the United States. Products carrying the accredited Forest Stewardship Council (FSC) label are printed on 100 percent FSC-certified paper.

NOV 1 2 2014